IMAGES
of America

SAN LUIS OBISPO
A HISTORY IN ARCHITECTURE

This book is dedicated to the memory of my parents,
Ted and Louise Penn.

Thank You

Thank you for shopping with us. If you are happy with your purchase, please leave "
"Positive Feedback" " for us. If you have any problem, please contact to us at "
"**fivephoenixes@yahoo.com**" . We will promptly resolve all issues.

Five Phoenixes (TKH Media)

IMAGES
of America

SAN LUIS OBISPO
A HISTORY IN ARCHITECTURE

Janet Penn Franks

ARCADIA

Published by Arcadia Publishing
Charleston SC, Chicago IL, Portsmouth NH, San Francisco CA

Printed in the United States of America

Library of Congress Catalog Card Number: 2004108141

For all general information contact Arcadia Publishing at:
Telephone 843-853-2070
Fax 843-853-0044
E-mail sales@arcadiapublishing.com
For customer service and orders:
Toll-Free 1-888-313-2665

Visit us on the Internet at www.arcadiapublishing.com

CONTENTS

ACKNOWLEDGMENTS

Many thanks to the San Luis Obispo County Museum and History Center for granting me unlimited access to the numerous articles, books, historic newspapers, phone directories, and photographs used in the preparation of this manuscript. Other research materials include *Looking Back Into the Middle Kingdom, San Luis Obispo County*, by Daniel E. Krieger; *Rails Across the Ranchos*, by Loren Nicholson; *Parade Along the Creek—Memories of Growing Up in San Luis Obispo*, by Rose McKeen; *San Luis Obispo Discoveries*, by Paul Tritenbach; *San Luis Obispo Tribune Souvenir Railroad Edition, May 5th, 1894*, published by The Library Associates, Robert E. Kennedy Library, California Polytechnic State University; *Memories of the Land*, by Mark P. Hall-Patton; the United States Census Bureau website <www.census.gov>; historian Lynne Landwehr's website <www.historyinslocounty.com>; and the City of San Luis Obispo's *Historic Resources Survey Report and Historical and Architectural Conservation Element*.

Individual thanks go to Ron Clarke, director of the San Luis Obispo County Museum and History Center; Dr. Dan Krieger, professor of history, California Polytechnic State University; Pierre Rademaker, Pierre Rademaker Design; Nels and Vicki Hanson; Laura and Gere di Zerega; and Jeff Hook, associate planner and landscape architect, City of San Luis Obispo Community Development Department. Thank you also to Georgia Adrian, the Heritage Inn; to Janet Baird, Country Classics; and to the Swift family, for allowing me to use your historic photos. And a special thank you to Steve and Jan Owens, publishers of *Journal* and *Plus* magazines, where I first developed my love of writing about historic San Luis Obispo.

All photos, except where noted, are courtesy of the San Luis Obispo County Museum and History Center (SLOCMHC), where copies may be purchased. Please contact the San Luis Obispo County Museum and History Center, 696 Monterey Street, San Luis Obispo, CA 93401, (805) 543-0638, <www.slochs.org>, slochs@kcbx.net.

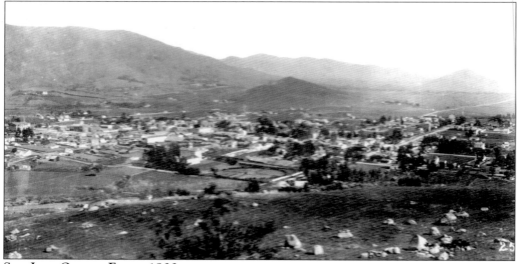

SAN LUIS OBISPO, EARLY 1900S.

INTRODUCTION

San Luis Obispo is one of California's oldest communities, founded by Father Junipero Serra in 1772 as Mission San Luis Obispo de Tolosa. Located eight miles inland from the Pacific Ocean, the city lies along California's Central Coast approximately halfway between San Francisco and Los Angeles. San Luis Obispo is bordered on the north and east by the rugged Santa Lucia Mountains and for more than 200 years remained largely separate from the outside world.

In the late 1890s, the old mission town grew into a full-fledged city with the arrival of the Southern Pacific Railroad. Daily runs from San Francisco began in 1894, and by 1901 trains continued south to Los Angeles. The railroad brought enormous changes to San Luis Obispo, increasing communication with the state's larger cities and facilitating the import of goods previously denied to the geographically isolated town. Construction materials could now be shipped by rail rather than by steamship or wagon, which resulted in the building of many impressive structures still prized for their distinguished architecture and blending of styles.

San Luis Obispo's architectural heritage can be traced to seven general building styles: Adobe, California Renaissance, Spanish, Contemporary Clapboard, Classical, Chicagoan, and Early American Commercial. The city's architecture between the 1870s and the 1940s largely paralleled trends across America, although designs reached the Central Coast a few years later and were not pure in form. San Luis Obispo's designs were an eclectic modification and combination of styles formed on the East Coast and in Europe. In the late 19th century, many of the city's buildings were planned by "carpenter designers" who followed explicit architectural instructions found in do-it-yourself pattern books. The choice of style reflected the structure's function and at times the owner's desire to make a social statement. The ready availability of materials also played an important role in the selection of architectural designs.

From the mission days until the mid-1800s, San Luis Obispo's first generation of structures was built of adobe bricks. Under the guidance of the mission padres, the Chumash Indians became skilled adobe craftsmen, building most of the town's early dwellings. Unfortunately, the moist coastal climate and seasonal freezing and thawing temperatures caused most of the adobes to eventually crumble. Tragic cultural events also brought an end to the use of adobe brick—by the 1850s, most of the native Chumash population had died of typhus, substantially reducing the number of adobe artisans. Indian craftsmen who survived the first epidemic later succumbed to cholera during the drought of the mid-1860s. Residents unable to rebuild their decaying adobe town turned to more durable building materials that became available with two important breakthroughs in local transportation.

Wood for construction first became readily obtainable in the late 1870s after the completion of the narrow-gauge Pacific Coast Railway, which transported goods and building supplies to San Luis Obispo from steamships that docked at Port Harford, present-day Port San Luis. Tracks ran from the coast to the city's southern end, where several lumberyards opened near the railway depot. Wood also began to arrive by land, with the construction of a graded road along Cuesta Pass through the Santa Lucia Mountains just north of San Luis Obispo. County Road No. 1—known today as Old Stagecoach Road—became an important overland gateway to the Central Coast and further increased the availability of wood building materials. Still, most of the town's wood supplies would continue to come via steamship and the Pacific Coast Railway, even after the completion of the tunnels on Cuesta Grade and the arrival of the Southern Pacific Railway from the north.

Wood construction withstood the elements better than adobe, but like clay it also had its limitations. Wood-frame structures dried out and became highly flammable. Fireplaces used for heating eventually set fire to, and destroyed most of, the town's wooden buildings. Hotels were

particularly vulnerable, as each room had its own fireplace, oil-burning lamps, and candles. In late-19th-century San Luis Obispo, building codes were nonexistent or extremely lax, and structures rarely received inspection for fire safety. Lax regulations were to blame for several major fires: the Andrews Hotel in 1886, the Ramona Hotel in 1905, the French Hotel in 1908, and the roof fire at the mission in 1920.

As climate (and catastrophic epidemic) caused the demise of the city's adobe period, fire spelled the end of widespread wood-frame construction, and San Luis Obispo's designers and builders turned to brick and stone. In the 1880s and 1890s, fireproof masonry buildings replaced old or incinerated wooden structures. Many of the new edifices were built of bricks manufactured at local yards, while other buildings were made of sandstone from Los Berros in the Arroyo Grande Valley, or granite from the rock quarries at nearby Bishop Peak.

Today, San Luis Obispo retains a few precious surviving examples of the "age of adobe," most notably the mission, the Sauer-Adams Adobe on Chorro Street, and the Dallidet Adobe on Pacific, all built by skilled Chumash craftsmen. Historic and well-preserved wooden structures, especially St. Stephen's Episcopal Church on Nipomo Street, as well as many multi-storied homes from the Victorian era, afford visitors a fascinating view of 19th-century architectural design. Perhaps most impressively, the age of brick and stone and a confluence of styles make San Luis Obispo's commercial district a living snapshot of an original, bustling, self-confident city in late-19th and early-20th-century California.

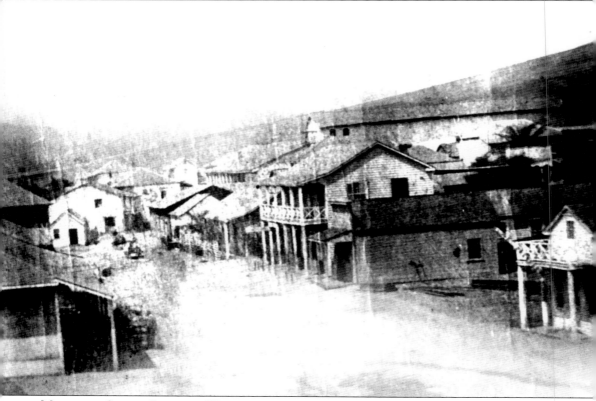

MONTEREY STREET LOOKING WEST, C. 1870.

One

THE DOWNTOWN
COMMERCIAL DISTRICT

San Luis Obispo's mid-19th-century townscape emerged along two main "streets" that formed an intersection near Mission San Luis Obispo de Tolosa: A dusty trail known as Monterey Street ran northeast from San Luis Obispo toward Cuesta Pass and the distant city of Monterey, while Chorro Street ran northwest through the Chorro Valley to the small settlements of Morro Bay and Cayucos along the coast.

In 1862, San Luis Obispo became a regular stop on the Overland Stagecoach Company's route between San Francisco and Los Angeles, and during the 1860s the isolated town grew in size and importance. With a county population of 1,782 (1860 census), the fledgling city included Mission San Luis Obispo de Tolosa, the nearby two-story home built by Capt. John Wilson (on the site of the future Carnegie Library), and several neighboring small adobes. A two-story restaurant and dance hall stood on the corner of Monterey and Chorro Streets, the Beebee and Pollard general merchandise store opened for business across the street, and the county's first wood-frame building rose just to the north. Three large adobes completed the town, the most impressive being Casa Grande, built by William G. Dana, a Boston sea captain, China tradesman, and Mexican land grantee. Also known as "Dana's Big House," the two-story building had a sheet-iron roof and served as a hotel, saloon, store, and courthouse. With the arrival of immigrants from across the country and abroad—many were Swiss, Italian, Chinese, and Portuguese from the Azores—San Luis Obispo grew rapidly. In 1870, San Luis Obispo County's population was 4,772, and by 1880 it had nearly doubled, to 9,142. Many of the newcomers were farmers and ranchers, and some of those who became successful built homes in the city's downtown.

By the late 1890s, the county's population had soared to 16,072. The city's business district now comprised a 15-block area bounded by Monterey, Osos, Higuera, and Nipomo Streets. Commercial buildings with distinctive architectural designs intermingled with private homes, and many residents lived in hotels and on the upper floors of retail shops and offices. Most structures were wooden, and a few were constructed of locally manufactured brick. The remainder were aging adobes, many with false wooden fronts and some with tin, iron, or galvanized metal roofs.

Architectural styles in the early downtown district included Adobe, Pioneer, Romanesque, Renaissance and Gothic Revival, Chicagoan, Mission and Spanish Colonial Revival, Mediterranean, and, as time went on, Early American Commercial and Art Deco.

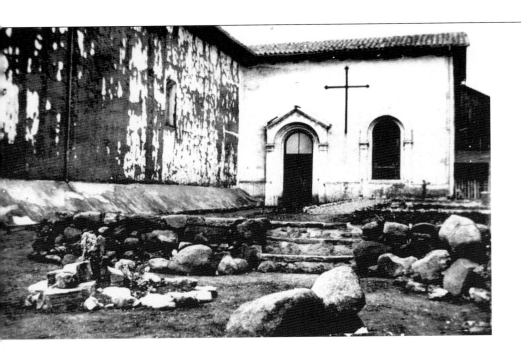

MISSION SAN LUIS OBISPO DE TOLOSA, CORNER OF MONTEREY AND CHORRO STREETS, C.
EARLY 1870S. Founded in 1772, Mission San Luis Obispo de Tolosa is San Luis Obispo's largest
and most impressive man-made landmark. It began as a few brush shelters along San Luis
Obispo Creek, where today Higuera and Marsh Streets intersect beside Highway 101. Twice
during the next four years the padres relocated the mission farther from the creek to avoid
continual flooding. The second and final move came in 1776, after the mission was nearly
destroyed by fire. The padres needed to rebuild most of the structure, and they chose the present
hilltop location on Monterey Street between Broad and Chorro, which was high above the
overflowing creek. Under the guidance of the mission priests, the Chumash Indians used brush
poles and tule reeds to build the "new" mission in an open-air, fort-like configuration with a
central courtyard. Several of its rooms had thatched-reed roofs. In 1794, a new, Spanish-style
adobe mission was completed. The Chumash Indians had learned to make adobe bricks by
mixing together sandy clay, water, and straw and placing the preparation into rectangular wood
forms. Once dry, the bricks were removed and allowed to bake in the sun for 10 to 14 days.

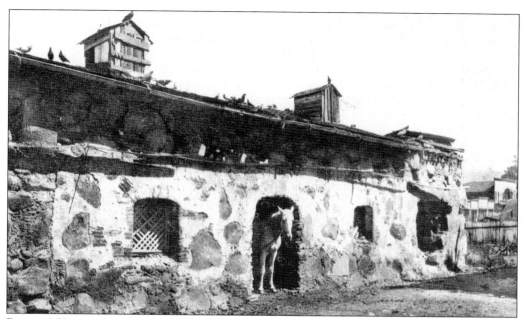

PADRES' KITCHEN, C. LATE 1800S. Irregular in plan, the mission comprised many structures, including a long, narrow church, quarters for the padres, workshops, corrals, and a granary. Over the years, the kitchen and other adobe outbuildings were constructed around the mission. Dr. William Hays, the town doctor from the late 1860s to 1890s, boarded his horse at the mission stables. Why the doctor's horse is photographed here in the kitchen is unknown.

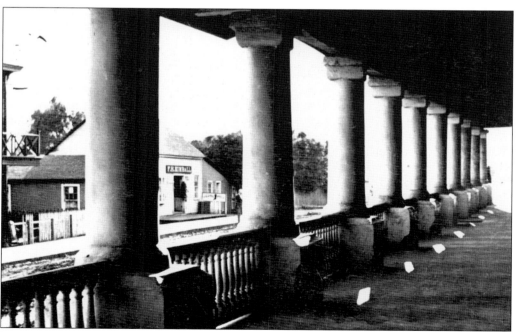

MISSION COLONNADE. About 1816, a front portico, belfry, and colonnade of 11 pillars were added across the front wing. The 11 pillars symbolized the 12 apostles—excluding Judas.

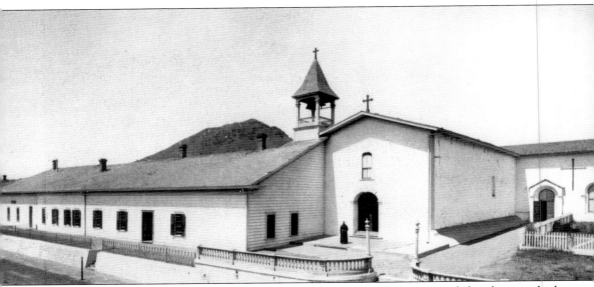

MISSION DURING NEW ENGLAND–CLAPBOARD PERIOD. By 1875, time and the elements had taken their toll on the more-than-80-year-old crumbling, adobe structure, and a major restoration began. The church bells were moved to a new wooden, New England–style belfry and the mission was resurfaced inside and out with clapboard siding. This unlikely combination of "Mediterranean style meets New England clapboard" kept the building dry but didn't allow the adobe to "breathe" and cool off on hot days. The clapboard siding created the perfect conditions for spontaneous combustion. A multitude of mysterious fires broke out at the mission in the early years of the 20th century. In 1920, faulty electrical wiring may have led to the fire that destroyed the mission roof, much of which still consisted of woven reeds. Ironically, the century-old oak rafters that had been tied in place with rawhide thongs remained standing and prevented the adobe walls from caving in. The fire left some of the original roof beams exposed, inspiring the padres to restore the mission in its original Spanish style.

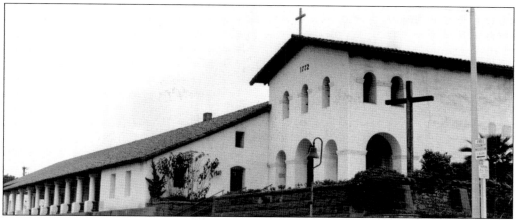

MISSION AFTER THE RESTORATION. An annual community celebration, La Fiesta de las Flores—"The Festival of the Flowers"—was begun in 1925 to raise money for the mission's restoration. William Randolph Hearst donated funds for the project that, due to the Depression, wouldn't begin for another nine years. Finally, in 1934, the wooden siding and New England–style belfry were stripped away and the original portico, colonnade, and roof tiles were reinstalled. The reconstructed adobe walls were heavily plastered and painted white, resurrecting the Spanish-style mission that exists today.

WALTER MURRAY ADOBE, MISSION PLAZA, C. EARLY 1920S. Probably built around 1850 by Chumash Indians who worked for the mission padres, the Walter Murray Adobe is one of the city's oldest structures and the birthplace of San Luis Obispo's first newspaper. The two-room, thick-walled, 16- by 27-foot structure stood on a large parcel of land that spanned San Luis Obispo Creek. The front of the adobe faced Monterey Street, which ran in front of the mission until Mission Plaza was completed in 1975. (Courtesy of the Carpenter Collection/SLOCMHC.)

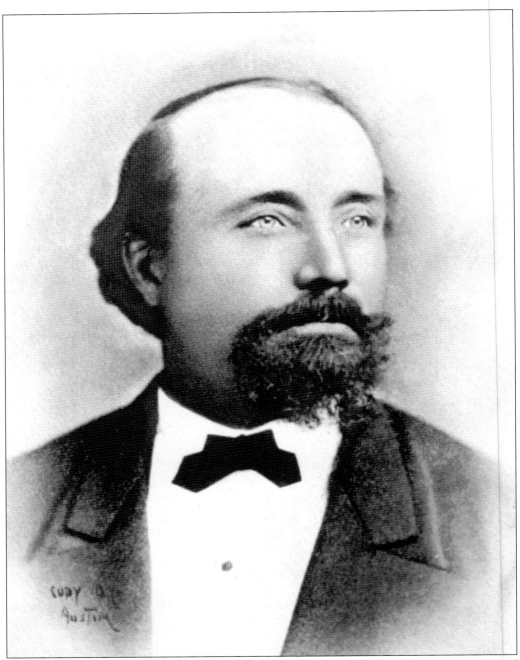

WALTER MURRAY. English-born Walter Murray, one of San Luis Obispo's most accomplished and influential citizens, purchased his adobe home around 1853. Walter and his wife, Mercedes, lived in the back room and used the front for an office. Walter was an attorney, a district court judge, the organizer of the Vigilance Committee of 1858 (a group of 148 men who, in response to the rampant crime in San Luis Obispo County, took the law into their own hands, with immediate results) and the co-founder of the *San Luis Obispo Tribune* newspaper. On August 7, 1869, Murray printed the first edition of the newspaper on his printing press in the adobe.

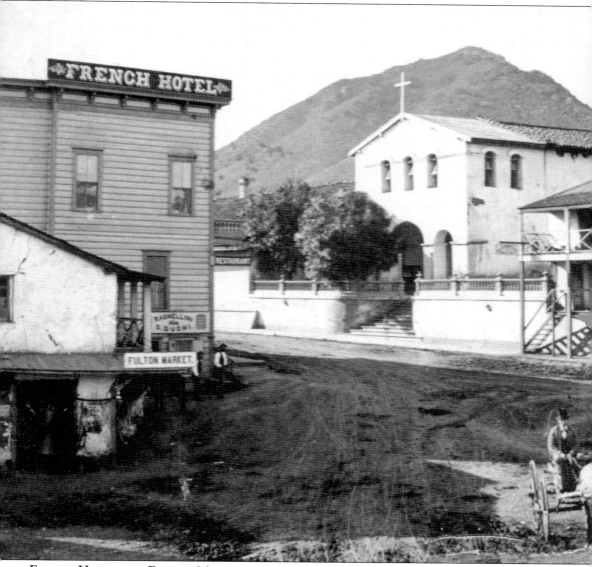

FRENCH HOTEL AND FULTON MARKET, MID- TO LATE 1870S. The French Hotel was among San Luis Obispo's earliest businesses and stood near the southwest corner of Monterey and Chorro Streets, conveniently sharing quarters with the Fulton Market, one of the town's first butcher shops. The French Hotel occupied an adobe structure probably built sometime in the 1850s. Joaquin Almada had owned and operated a general merchandise and liquor store in the building until the late 1860s. His store also functioned as a meeting place for townspeople as well as for "wild bands of murderous cutthroats" who frequented the store late at night, according to accounts in the *San Luis Obispo Tribune*. In the late 1860s, French-born Louis Pillard purchased the adobe, enlarged it, and transformed it into a hotel. The French Hotel offered long-term residency as well as overnight lodging, although some guests complained that the clanging of the mission bells disturbed their slumbers. The hotel had a bakery and a first-class restaurant that claimed distinction for its "unusual" (French) cuisine that was served with wine.

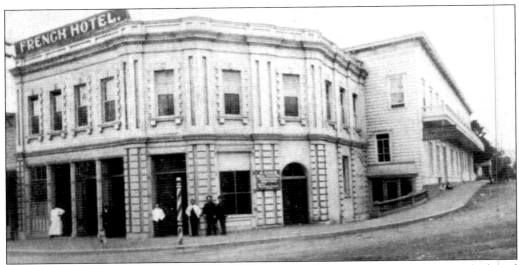

FRENCH HOTEL, C. 1904. By the 1870s, the French Hotel included an adjacent clapboard building, pictured on the right, and an annex on the second floor of the neighboring Lasar Building, pictured on the left. Today, the Mission Grill restaurant occupies the site.

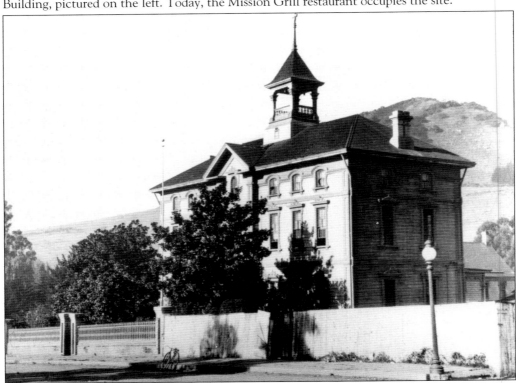

ACADEMY OF THE IMMACULATE HEART, C. 1904. In 1876, the Academy of the Immaculate Heart was built on the northwest corner of Broad and Palm Streets. The Catholic school also served as a convent for the sisters who taught there. In 1925, the school was moved up Broad Street, where it functioned as an apartment building and a grocery store until it burned down in 1939.

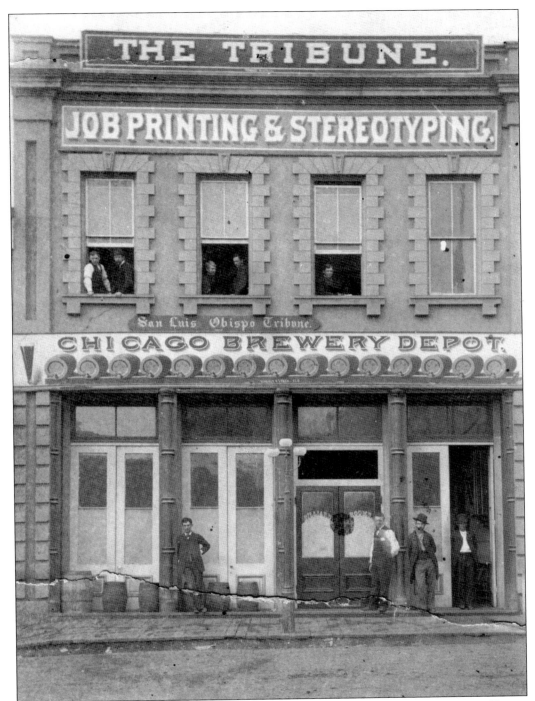

LASAR BUILDING, SOUTHWEST CORNER OF MONTEREY AND CHORRO STREETS, EARLY 1880s. The second floor of the Lasar Building originally housed the French Hotel annex and the offices of the *San Luis Obispo Tribune*. The Chicago Brewery occupied the ground floor.

LASAR BUILDING, EARLY 20TH CENTURY. Later, a series of automotive businesses occupied the Lasar Building, including Steve Zegar's Taxi Service. Zegar, William Randolph Hearst's personal chauffeur, regularly shuttled dignitaries and movie stars from San Luis Obispo to Hearst Castle.

ONE-STORY ADOBE. This adobe once stood on the Corner of Nipomo and Dana Streets and served as an Overland Stage Company stop in the 1860s. The building was torn down about 1929 to make way for the Harmony Creamery.

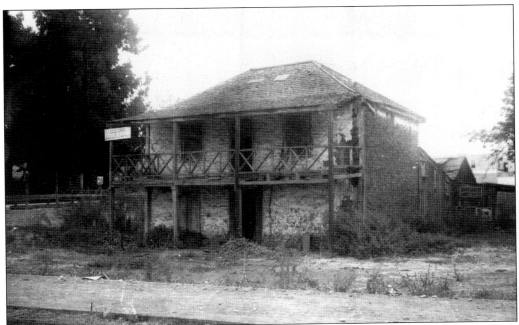

GARCIA ADOBE, CORNER OF OSOS AND HIGUERA STREETS. Some adobes had two stories, like the 1860s Garcia Adobe that was once a mission outbuilding.

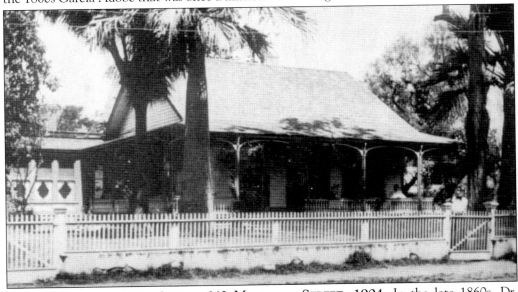

HAYS-LATIMER-LEITCHER ADOBE, 642 MONTEREY STREET, 1904. In the late 1860s, Dr. William Hays purchased a newly built adobe on Monterey Street, a few doors west of the mission. Hays made house calls to the sick on horseback, carrying medical instruments and whiskey (which he used as a painkiller) in his saddlebags. A kind and modest man, Hays billed only those patients capable of paying for his services; he sent the others an invoice with the words "Charged to the Treasury of Heaven" written across the top. In 1903, B.G. Latimer, the owner of Booth and Latimer Drugs, purchased the home. Robert and Elizabeth Leitcher became the owners in 1957, and David Hannings in 2001.

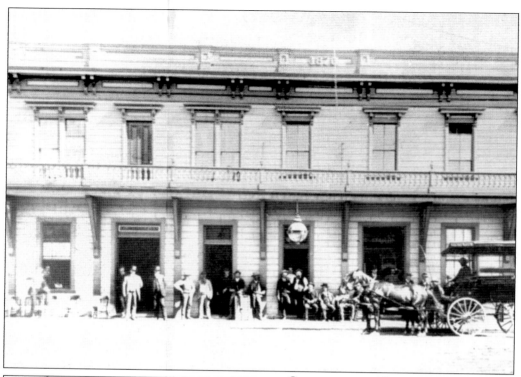

COSMOPOLITAN HOTEL, EARLY 1870S. The Cosmopolitan Hotel opened in the early 1870s the south side of Monterey Street between Morro and Chorro. Comprising 30 "sleeping apartments," 9 bathrooms, a saloon, a reading room, and a dining hall, the establishment was described by the *San Luis Obispo Tribune* as "the excelsior hotel of the southern coast." In later years, the Cosmopolitan became the St. James Hotel, and in 1933 a massive fire destroyed the building.

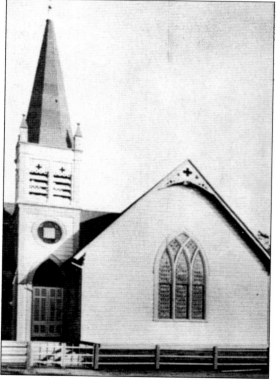

CONGREGATIONAL CHURCH, 1904. One of San Luis Obispo's early places of worship, the Congregational Church stood at 865 Marsh Street. The 1901 *San Luis Obispo City and County Directory* listing read: "Congregational Church, Rev. Geo. Willett, pastor. Services at 11:00 a.m. and 7:30 p.m.. The Stranger's Sabbath home. Good music. Seats free." Today, the San Luis Obispo Post Office annex occupies the site.

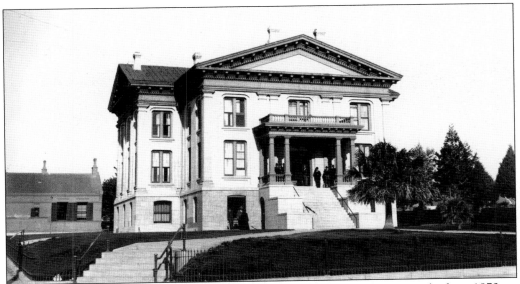

GREEK REVIVAL COURTHOUSE. San Luis Obispo's first "real" courthouse was built in 1873 on the northeast corner of Monterey and Osos Streets. Constructed of thousands of bricks from the Ah Louis Brickyard, the Greek Revival–style courthouse had three stories, formal front-entrance steps, and a portico supported with classic columns. Simulated columns uniformly positioned around the exterior of the building supported a classic cornice. The oversized, double-hung windows—remembered mostly for their tendency to rattle—added to the building's strict sense of symmetry.

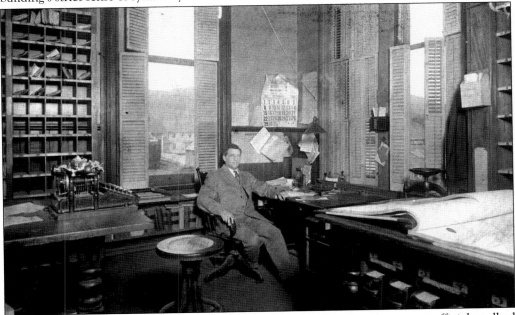

COURTHOUSE OFFICE. Inside the Greek Revival–style courthouse, government officials walked on tongue-and-groove wood floors and worked in offices accented with dark-stained wainscotting and moulding. Fireplaces in all the major rooms kept the courthouse warm during the winter.

21

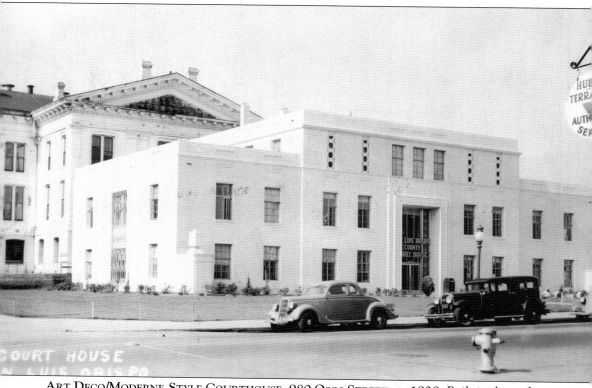

ART DECO/MODERNE-STYLE COURTHOUSE, 980 OSOS STREET, C. 1939. Built in three phases over a span of five years and completed in 1941, San Luis Obispo's new courthouse was a large, multi-storied, symmetrical Art Deco/Moderne-style building. Phase two of the building is pictured here facing Monterey Street with the old Greek Revival courthouse behind it. The courthouse featured vertical windows, recessed panels, terra cotta decorations, and iron grillwork. The lower floors housed the courtrooms and offices, and the top floor was used for the jail. During the 1950s, a saloon named "The Irishman" was located across from the courthouse on Osos Street. The bar's patrons reportedly threw beer bottles—presumably after drinking the contents—at the inmates who yelled at them from jail-cell windows.

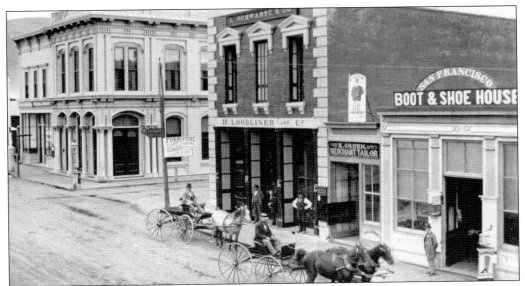

H. Loobliner & Company, 969 Monterey Street, Early 1900s. The H. Loobliner & Company Building, *c.* 1874, was one of the oldest commercial buildings standing in San Luis Obispo until it was razed in 2005. Early occupants of the three-story brick building included the Loobliner mercantile on the first floor, the Odd Fellows Hall on the second, and the offices for Schwartz and Beebee Lumber Company on the third. From 1902 to the mid-1920s, the first floor was used as the city's post office. (Courtesy of the Carpenter Collection/SLOCMHC.)

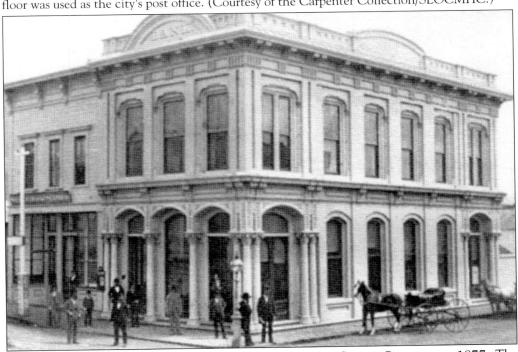

Bank of San Luis Obispo, Corner of Monterey and Court Streets, c. 1877. The Bank of San Luis Obispo, one of the city's early banks, stood across the street from the Loobliner building.

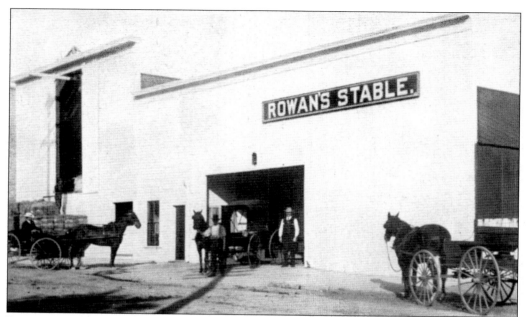

ROWAN'S STABLE. One of several liveries in town, Rowan's Stable operated at 977 Higuera Street.

SAUER-ADAMS ADOBE, 964 CHORRO STREET, 1930S. Built about 1800 as part of the mission complex, the Sauer-Adams Adobe became home to grocery merchant George Sauer and his family in the 1860s. In later years, the building functioned as a restaurant, a bowling alley, and the St. Charles Hotel. During the Prohibition era of the Roaring 20s and early 1930s, many local citizens believed the adobe served as a speakeasy, a residence for bootleggers, and a "front" for the oldest profession in the world. In 1940, writer and preservationist Helen Adams bought the adobe, restored it, and lived there with her daughter Genevieve Goff and grandson Alex Gough. (Courtesy of the Carpenter Collection/SLOCMHC.)

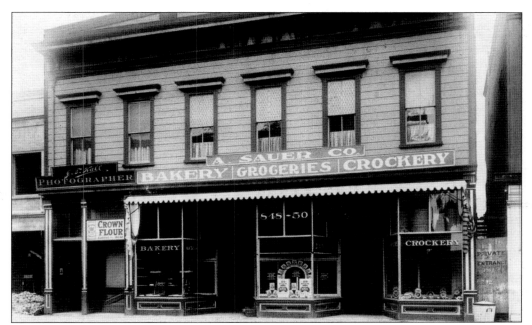

A. SAUER & COMPANY GROCERY AND BAKERY, 848 MONTEREY STREET, C. 1900.
Constructed about 1875, the Italianate two-story structure on Monterey Street housed the A.
Sauer & Company grocery and bakery. Owned and operated by German-born brothers George
and Andrew Sauer, the store also sold sundries, tinware, and crockery. The George Sauer family
lived conveniently around the corner at 964 Chorro Street, in what is today known as
the Sauer-Adams Adobe. Andrew Sauer and his family lived on the corner of Marsh and
Chorro Streets.

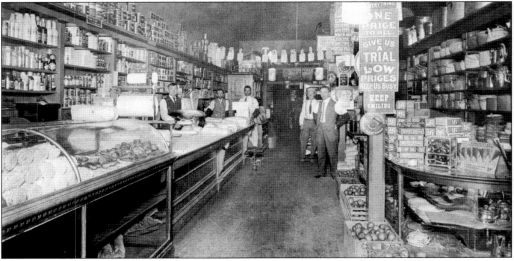

A. SAUER & COMPANY GROCERY AND BAKERY INTERIOR. Early, prepackaged groceries
included Van Camp Pork and Beans and Post Toasties, while popular cleaning products were
Old Dutch Cleanser and 20 Mule Team Borax. Among a myriad of signs that hung inside the
store, one read: "If you don't c what u want, ask 4 it; we keep the best of everything. One price
to all; give us a trial; low prices keep us busy; don't forget the little folks at home."

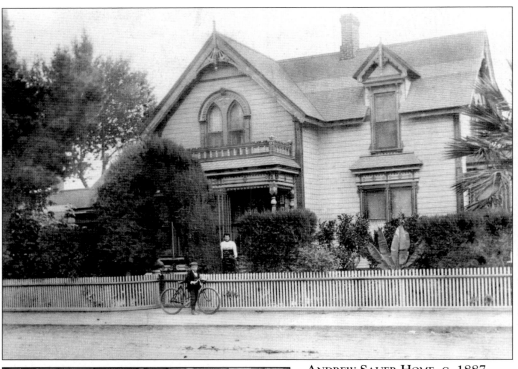

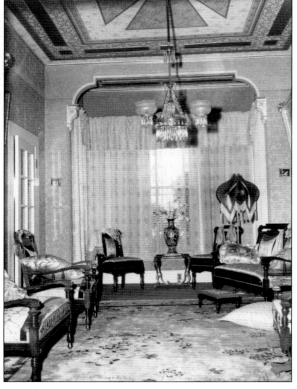

ANDREW SAUER HOME, C. 1887. The prosperous Andrew Sauer family lived in a grand house on the southwest corner of Marsh and Chorro Streets, several blocks from the Sauer grocery. The house had originally been built nearby on Higuera Street and was moved around the corner after Sauer bought his homesite. Pictured here at the front of her impressive home are Mrs. Sauer and her son, who is seated on his bicycle.

ANDREW SAUER HOME PARLOR. The Sauers' parlor reflected the family's prominent social position. The Sauers ate their meals on porcelain china, drank from crystal glasses, and sat upon furniture upholstered with the finest fabrics. As in most Victorian parlors of the era, the shades were usually drawn to protect the carpets and furnishings from fading. The doors were kept closed and only opened for company and special occasions.

JACK HOUSE, 536 MARSH STREET. One of San Luis Obispo's most impressive residences, the Jack House embodied a spirit of elegance and social prominence. Built *c.* 1875 by affluent civic leaders Robert and Nellie Jack, the two-story Italianate house had a highly decorative boxed cornice with dentils and brackets and a distinctive frieze. Water pipes ran along the home's exterior walls—the house was constructed before the advent of indoor plumbing. Servants drew water for cooking with a manually operated water pump located in the backyard. Inside the mansion, 12-foot ceilings and 8-foot doors created a sense of grandeur. The fireplaces were small, burning coal instead of wood. Robert Jack was active in ranching, politics, banking, and land development. Nellie, his wife, was known for her excellent education and fine book collection. The Jacks entertained numerous guests at their home, including railroad magnates Charles Crocker and C.P. Huntington, pianist Ignace Paderewski, and humorist Will Rogers. Over a span of more than 90 years, several generations of the Jack family lived in the Victorian-style home. (Courtesy of the City of San Luis Obispo, Community Development Department.)

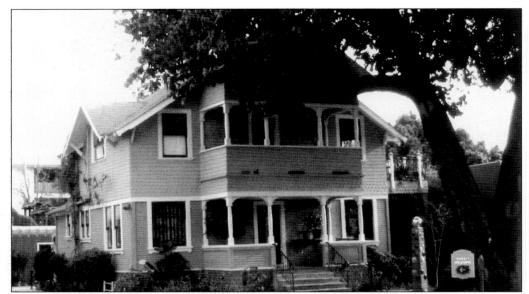

KAETZEL HOUSE, 547 MARSH STREET, 2004. In the early 1900s, Robert and Nellie Jack's daughter Gertrude married attorney Charles Kaetzel. The Jacks presented the newlyweds with a house across the street from their own. Built sometime before 1886 and extensively remodeled for the young couple, the Carpenter Gothic Revival house had elements of Queen Anne styling. The Kaetzels lived in the home with their four children, who communicated with their nearby relatives via written messages sent on wires they'd strung across Marsh Street. (Courtesy of the Franks Collection.)

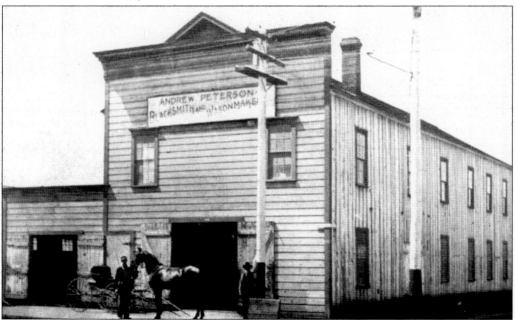

ANDREW PETERSON—BLACKSMITH, WAGONMAKER, AND HORSESHOER—CORNER OF BROAD AND MARSH STREETS. Up the street from the Kaetzel and Jack homes, Andrew Peterson's Blacksmith Shop was one of several in town.

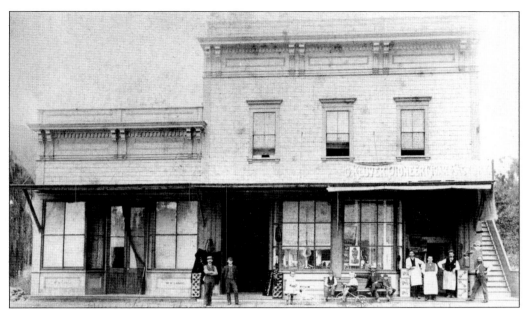

KLUVER & SON PIONEER CIGAR FACTORY. German immigrant George Kluver founded Kluver & Son Pioneer Cigar Factory *c.* 1879 on the ground floor of a wood-framed structure near the northeast corner of Nipomo and Higuera Streets. For more than 40 years, Kluver & Son provided San Luis Obispo's gentlemen with the factory's own Pioneer-brand cigars. Kluver held one of the earliest federal permits to manufacture cigars in California, importing the cigar bands from Germany, the only country at that time that had a technique for printing gold on paper.

KLUVER'S CIGAR FACTORY, FORMER SITE AT 726 HIGUERA STREET. In 1897, after his father's death, Fred Kluver moved the cigar factory up the street to a newly constructed building, renaming the business Kluver's Cigar Factory. The red-brick Early American–Commercial edifice had a false front, a gable parapet, and two iron columns that framed the front windows. The basement functioned as the manufacturing site for the factory's hand-rolled cigars.

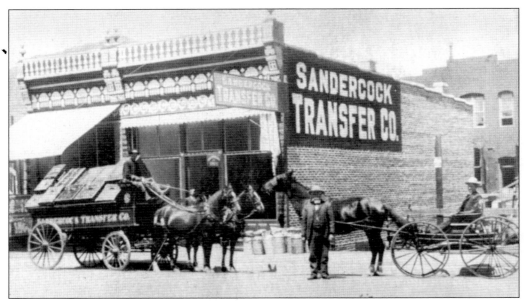

SANDERCOCK TRANSFER COMPANY, 852–856 HIGUERA STREET. Founded in 1872, William Sandercock's drayage company delivered freight for the Pacific Coast Railway and granite quarried at Bishop Peak. In the early 1880s, Sandercock built an Italianate/Pioneer, false-front brick building on Higuera Street to house the Sandercock Transfer Company. The warehouse had a decorative cornice and parapet, accentuated by highly ornamental Victorian appliqués and finials. In later years, the company made deliveries to local businesses.

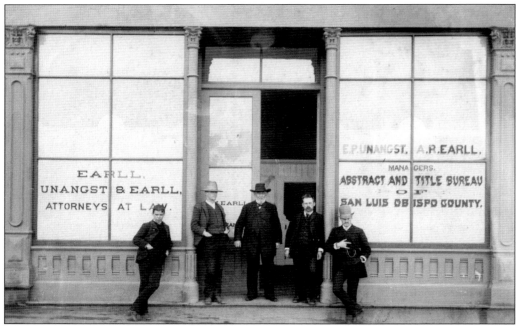

UNANGST ABSTRACT OFFICE, 1880S. Judge Edwin Unangst, fourth from left, owned and operated one of San Luis Obispo County's first abstract and title bureaus.

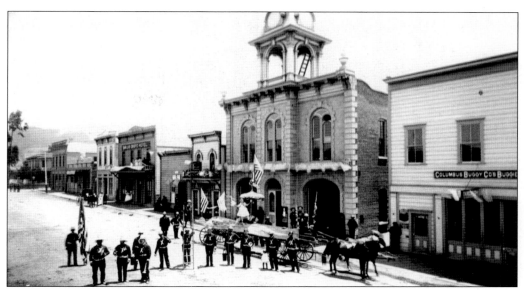

HIGUERA STREET FIRE DEPARTMENT, 867 HIGUERA STREET. The San Luis Obispo Fire Department began operating from the City Hall building on Higuera Street in 1879. The ground floor housed the fire equipment, and the fire bell was located in a tower on the roof. The hook-and-ladder wagon, hand pump, and hose cart were concealed behind two sets of large double doors that opened onto the street. In the department's early years, firemen on foot pulled the wagons to the fire; horses pulled the equipment only in parades.

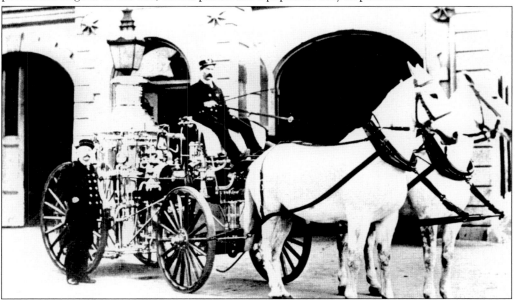

FRANK AND ROWDY. Firefighting in San Luis Obispo became a little easier in the early 1890s when the city purchased a potbellied steam pumper and two Percheron horses to pull it. Frank and Rowdy, the equine members of the firefighting team, lived in the firehouse. Above the horses, racks held their harnesses to allow for quick hitch-ups. Sometimes Frank and Rowdy became so excited by the fire bell that they ran out of the building before the firemen could hitch them to the wagon.

31

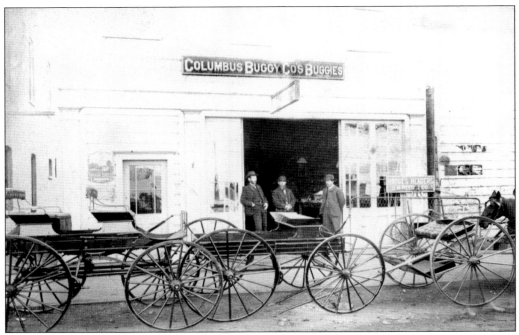

COLUMBUS BUGGY COMPANY. The Columbus Buggy Company once stood on the south side of Higuera Street, next to the San Luis Obispo Fire Department.

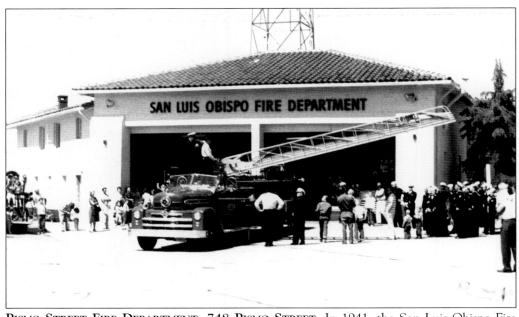

PISMO STREET FIRE DEPARTMENT, 748 PISMO STREET. In 1941, the San Luis Obispo Fire Department moved to a new fire station on the northwest corner of Pismo and Garden Streets.

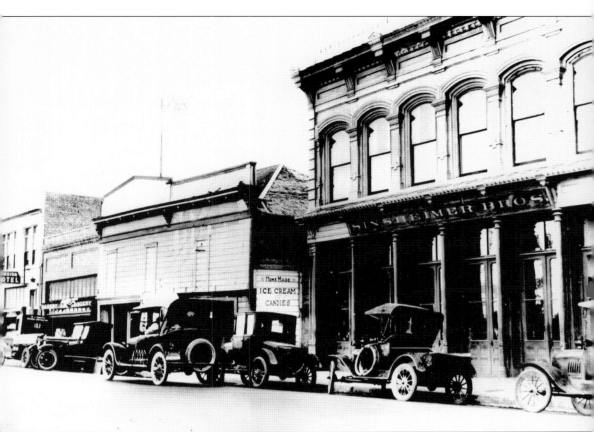

Sinsheimer Brothers Mercantile, 849 Monterey Street, Early 1900s. One of the city's most appealing and interesting structures from a bygone era is the 1884 Sinsheimer Brothers building on Monterey Street. Built by three German-born brothers—Bernard, Henry, and "A.Z."—the elaborate construction remains a stunning example of a classic 19th-century mercantile store. Oakland-based architects, Veitch, Knowles, & Company, designed the two-story Italianate building, which cost $8,600 to construct. Made of locally manufactured brick, the 4,000-square-foot rectangular structure had a flat roof and thick walls. Six pairs of elongated, double French entrance doors complemented six Islamic, segmental-arch windows to create a formal and symmetrical storefront. Scalloped awnings with tiebacks above each entrance door protected the mercantile from the late afternoon sun. A magnificent cast-iron, first-floor façade, consisting of classic columns and fluted pilasters, gave the building its most amazing feature. Manufactured by Iron City Works in San Francisco, the façade was shipped to Port Harford—now Port San Luis—and then was brought over land in sections to San Luis Obispo. Heavy iron window shutters at the rear of the building provided protection against fire and theft.

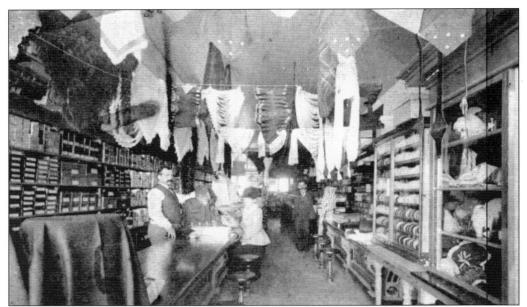

SINSHEIMER BROTHERS, STORE INTERIOR, C. 1890. Cast-iron columns standing in the building's interior allowed the store to span a width of 40 feet, an architectural feat in the 19th century. Long wooden counters reached the length of the building and customers sat on stools while clerks filled their orders. Gaslights hung from the high ceiling, where a "Lampson" money carrier—a forerunner to the later "zip tube"—was connected to a conveyor belt. Clerks put the sales slip and the customer's money into a small wooden cup and pulled a cord that sent the cup to the back office. Office workers put the proper change in the cup and sent it back to the clerk. (Courtesy of the Baird Collection.)

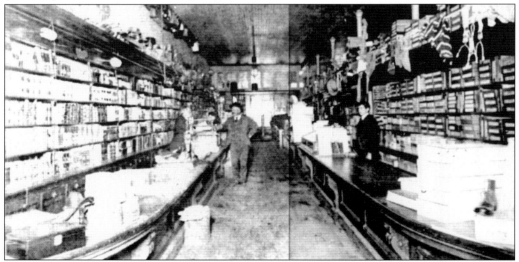

SINSHEIMER BROTHERS, STORE INTERIOR, EARLY 1900S. The Sinsheimer brothers attracted customers with a wide variety of merchandise and their willingness to trade goods for gold dust, beans, grain, and cattle. Known as "the place to go if you can't find it anywhere else," the mercantile sold grocery staples, ready-made clothing, textiles, and tools, as well as heavy equipment kept in a brick warehouse behind the store. (Courtesy of the Baird Collection.)

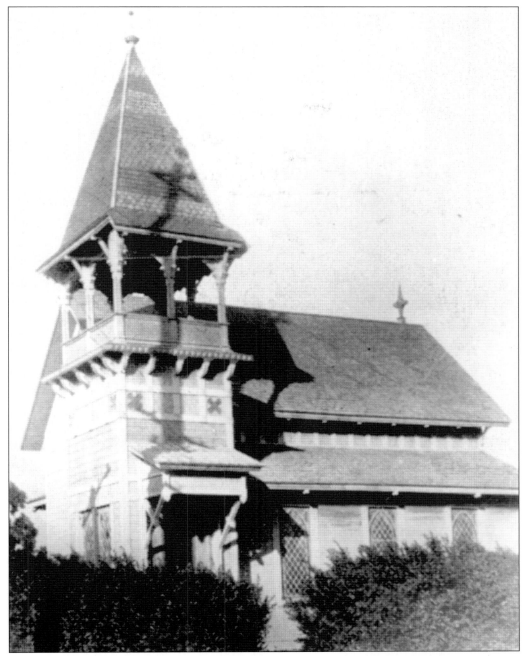

First Presbyterian Church, the First Sanctuary, 981 Marsh Street. Civil War veteran Judge McDowell Venable founded the First Presbyterian Church in San Luis Obispo in 1875. From 1884 to 1905, the small congregation worshiped in the 200-seat redwood sanctuary on the southeast corner of Marsh and Morro Streets. The church had an imitation stained-glass window and an imposing bell tower with a steeple. Best of all, it had carpeted aisles so that women dressed in their Sunday finest wouldn't have to worry about dragging their trains on the dusty floor.

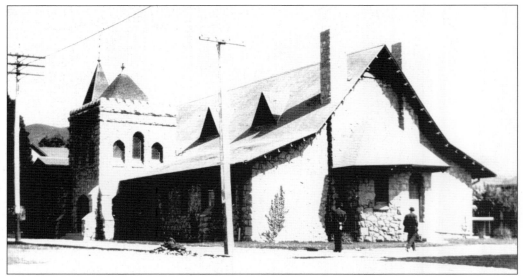

FIRST PRESBYTERIAN CHURCH, 981 MARSH STREET, C. 1905. Completed in 1905, the new First Presbyterian Church was constructed of blue granite quarried at Bishop Peak and featured a steeply pitched roof with flared eaves, triangular dormers, and a two-story tower with stained-glass windows that housed the pastor's study.

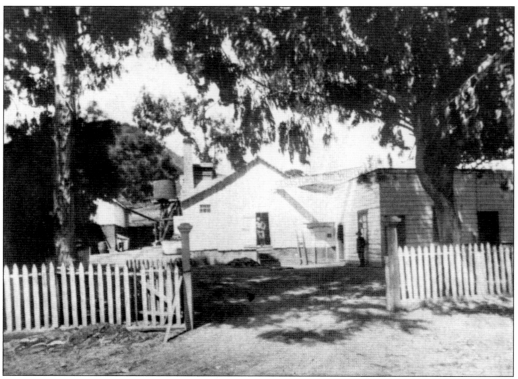

SEBASTOPOL BREWERY. The Sebastopol Brewery was once located on Nipomo Street.

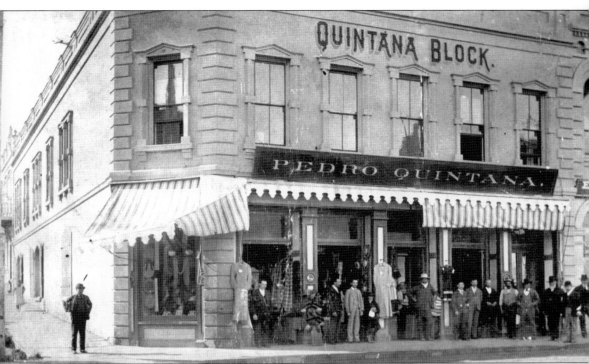

QUINTANA BLOCK, AT THE NORTHEAST CORNER OF CHORRO AND MONTEREY STREETS. In the late 19th century, Pedro Quintana operated his clothing store in the Quintana Block at the corner of Chorro and Monterey Streets. Later, the Donati, Righetti & Codoni department store took over the site, offering San Luis Obispians a variety of merchandise. The *San Luis Obispo Tribune* announced, "In one of the best locations in town [Donati, Righetti & Codoni] have installed a stock of clothing, dry goods, furnishings, groceries, provisions with accessories, and at a price that must appeal to the buyer of the necessaries of life as without a peer in San Luis Obispo. The people are reaping the benefits." In later years, the second floor of the building housed the Blackstone Hotel.

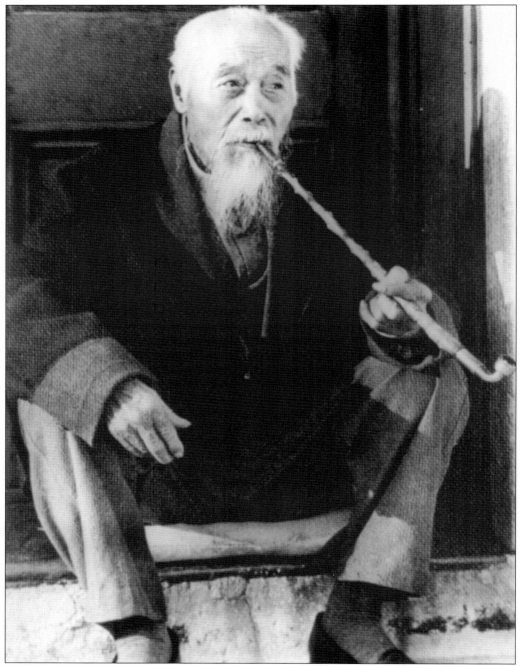

Ah Louis, c. 1920. Ah Louis, the unofficial "Mayor of Chinatown," migrated from China in 1870 and became a benefactor for his countrymen, contracting thousands of Chinese who eventually built a large portion of San Luis Obispo County's roads, wharves, and railroad lines. The enterprising Ah Louis also helped build the city and give it cultural shape with his diverse business ventures. He mined quicksilver, established San Luis Obispo's first brickyard, bred racehorses, became a dairyman, and cultivated a vegetable and seed farm.

CHINATOWN, 1930S. Chinatown was a self-sufficient micro-culture that spanned the 800 block of Palm Street with boarding houses, restaurants, stores, and a joss house (a Chinese temple). In their native dress, the Chinese—who were mostly laborers—walked the wood-planked sidewalks, sometimes paused to sit and smoke long tobacco pipes in doorways facing the street, and gambled in the boarding houses' back rooms. Gambling was one of the few recreations available to San Luis Obispo's Chinese residents.

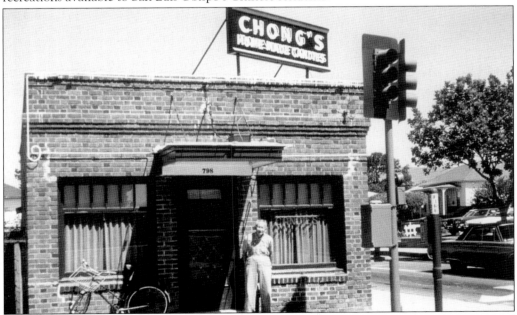

CHONG'S CANDY STORE, 798 PALM STREET. In 1925, Addison and Mary Chong opened Chong's Restaurant in this brick building at the west end of Chinatown. In 1950, Addison's brother Richard took over the building and converted it into a retail store where he operated Chong's Candy Store until his death in 1978. Richard was affectionately known as "the candy man."

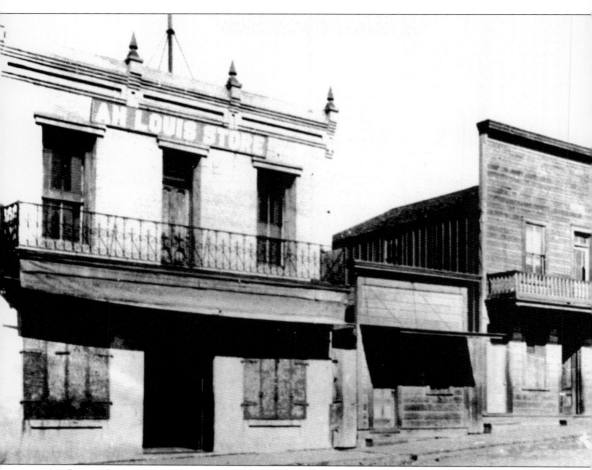

AH LOUIS STORE, 800 PALM STREET, 1930s. In 1885, Ah Louis built a mercantile with bricks from his brickyard on the northeast corner of Palm and Chorro Streets. The Ah Louis Store served San Luis Obispo's Chinese population and functioned not only as a place to purchase supplies, but also as a bank, post office, employment office, pharmacy, and general meeting place. The two-story, rectangular structure had 18-inch-thick walls, a projecting iron-railed piazza, and four finials that trimmed the roof. Deeply set windows allowed unobstructed views of the street and iron shutters offered protection from fire, theft, and the occasional stray bullet. Along the east wall of the store's interior, glass doors and shutters opened onto shelves stocked with Chinese foodstuffs, as well as the usual "American" groceries and sundries. On the opposite wall, apothecary drawers contained more than 800 Chinese herbs and spices for cooking and medicinal purposes. A wire cage at the end of the counter served as a bank from which Ah Louis paid his employees, accepted savings-account deposits, and loaned money—often on favorable terms.

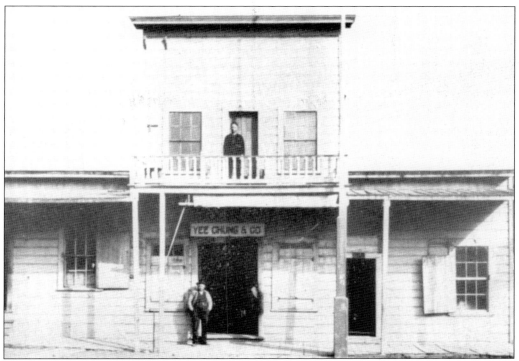

YEE CHUNG STORE. The Yee Chung store was one of several general-merchandise stores in San Luis Obispo's Chinatown.

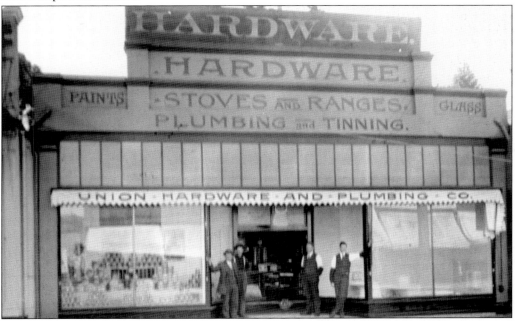

UNION HARDWARE AND PLUMBING, 725–727 HIGUERA STREET. The Union Hardware and Plumbing Company had two locations, one at 725–727 Higuera Street, shown in this photo, and one at 1119 Garden.

GOLDTREE HOUSE, 1212 GARDEN STREET, C. 1891. In 1887, downtown merchant Morris Goldtree and his wife, Helena, purchased a lot on Garden Street for $975 in gold coin. They built a beautiful Italianate home, which they sold 11 years later to Patrick and Elizabeth McCaffrey. The McCaffreys added a second story and divided the structure into four flats. Reconfigured into eight apartments in 1923, the building was extensively remodeled again *c.* 1990, when it became the Garden Street Inn, a bed-and-breakfast.

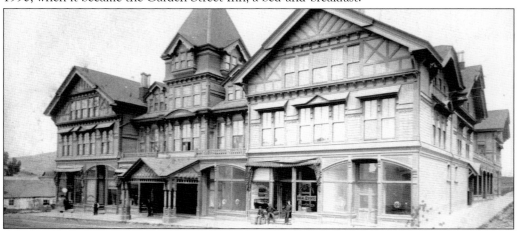

THE FIRST ANDREWS HOTEL, 998 MONTEREY STREET, C. 1886. Prominent rancher and banker J.P. Andrews built the elegant three-story Andrews Hotel on the corner of Monterey and Osos Streets in 1886. Andrews anticipated an influx of affluent travelers that the impending arrival of the Southern Pacific Railroad would bring to San Luis Obispo and spared no expense in the hotel's elaborately appointed 26 suites, 86 single rooms, and 16 bathrooms. Unfortunately, San Luis Obispo's worst fire to date completely destroyed the hotel after it had been in operation for only seven months.

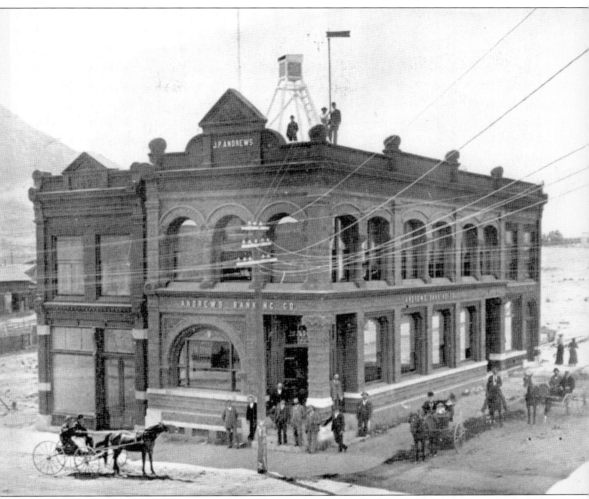

ANDREWS BANK, 998 MONTEREY STREET, 1890S. In 1894, J.P. Andrews constructed the Andrews Bank building on the northwest corner of Monterey and Osos Streets. The Romanesque Revival–style structure had a variety of arched and rectangular windows, granite and terra cotta ornaments, and decorative detailing. Its granite steps led to an angled, recessed corner that created a secluded yet elegant entrance. Best of all, the two-story brick building was "fireproof."

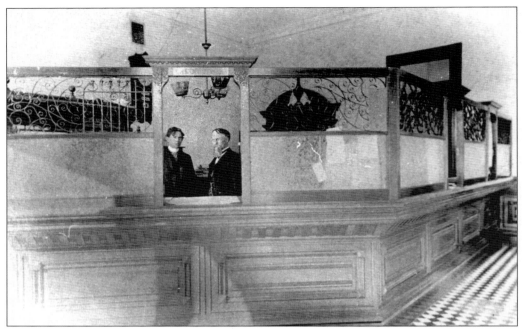

ANDREWS BANK, TELLER'S WINDOW. Inside the bank, customers walked across a black-and-white-checkered floor to the beautifully paneled counter and tellers' windows flanked by partitions of opaque glass and intricate grillwork. A massive iron door concealed the fireproof vault and a combination time-lock safe large enough to hold $100,000 in gold coin.

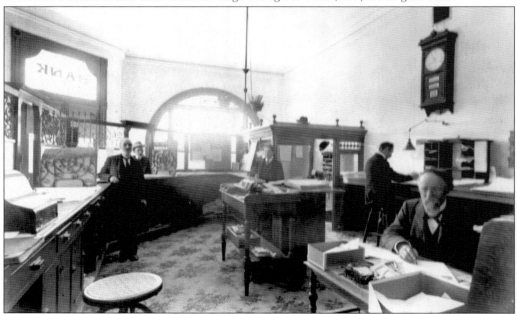

ANDREWS BANK, OFFICE. The elegantly furnished and carpeted bank offices were illuminated by electric lights. A large steam furnace in the basement heated the building in the winter. The Andrews Bank occupied the building's first floor, and until 1905 the city's first public library occupied the second.

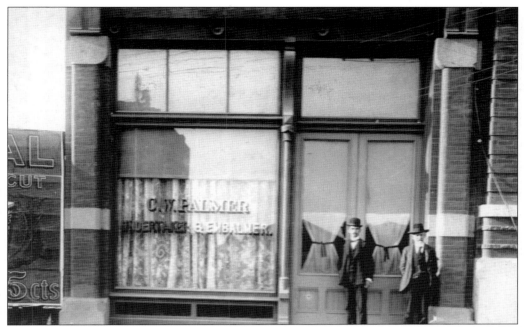

C.W. Palmer, Undertaker and Embalmer. In subsequent years, Andrews built a series of two-story brick additions, completing the entire complex in 1906. The new, adjoining buildings housed a variety of businesses, including C.W. Palmer, undertaker and embalmer. (Courtesy of the Carpenter Collection/SLOCMHC.)

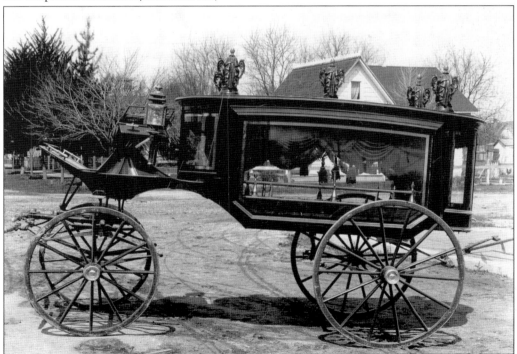

C.W. Palmer Hearse.

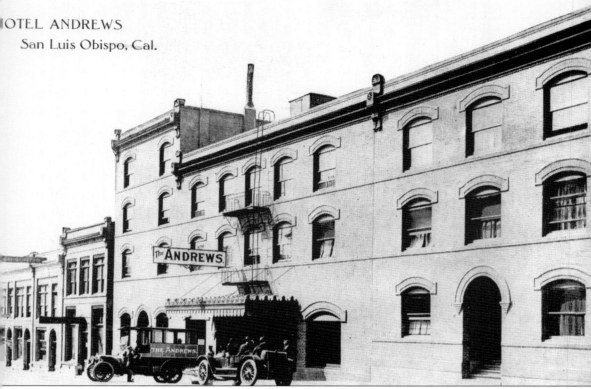

HOTEL ANDREWS
San Luis Obispo, Cal.

THE SECOND ANDREWS HOTEL. In 1910, J.P. Andrews built an unassuming, three-story hotel up the street from the Andrews Bank on the corner of Osos and Palm. Shortly thereafter, Andrews constructed a three-story and then a four-story addition. Together, the three hotels were named the "Hotel Andrews," a reference to Andrews' 1886 hotel that had burned down more than two decades before (see page 42). The 1911 *Morning Tribune* notified San Luis Obispians that the Hotel Andrews had a "new addition open, increasing our accommodations to 80 rooms, 30 with private baths" that each offered "hot and cold running water." Every room was "steam heated" and provided "telephone service." The Hotel Andrews hosted many banquets and special events. The large dining room featured multi-course meals where a "Merchant's Lunch" cost 50¢ and a "Table d'Hôte Dinner" 75¢. The saloon had a long, polished oak bar, and the dark-paneled, heavily draped lobby contained a technological marvel—the town's first elevator. Ever the consummate banker, J.P. Andrews installed a large Hewson safe in a room just off the lobby. The safe, larger than the room's doors or windows, was apparently installed first and the room built around it.

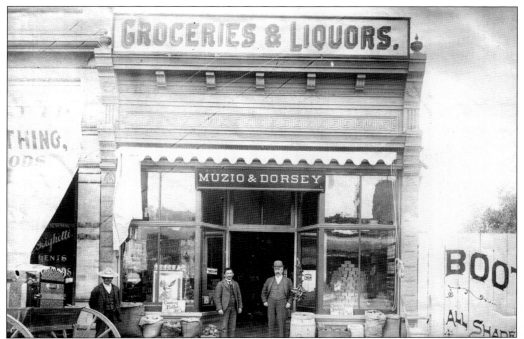

MUZIO & DORSEY GROCERY. Italian immigrant David Muzio began his successful grocery and liquor business on Monterey Street near the mission in 1888. Muzio's downtown establishment stood near cobbler shops, livery stables, hotels, and other stores and services common to a small but bustling western town toward the end of the 19th century.

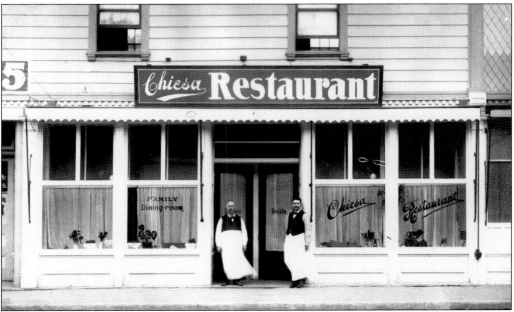

CHIESA'S RESTAURANT. Italian-Swiss immigrant Fernando Chiesa owned Chiesa's Restaurant, which stood across from Muzio's Grocery on Monterey Street. The café served oysters "in all styles" and stayed open 365 days a year.

MUZIO'S GROCERY, 870 MONTEREY STREET, 2003. In 1912, Muzio and Chiesa collaborated on a new building that would house both Muzio's Grocery (870 Monterey) and Chiesa's Restaurant (868 Monterey). The two men instructed architects Righetti and Headman of San Francisco to design a structure that would provide "an air of respectability and acceptable social standing" for the grocery and restaurant. The handsomely detailed Commercial Classical Revival building was made of yellow bricks, and its front walls had marble facing below the plate-glass windows. Steel shutters provided protection from fire and theft, as well as a shield to ward off stray bullets from frequent gunfights at a nearby saloon. The two-story rectangular building had a central wall that divided the ground floor into two separate spaces. Chiesa's Restaurant occupied the west side of the building, Muzio's Grocery the east side. Detailed brickwork on the building's exterior visually separated each business as well as the upstairs apartments. A striped awning extended over the sidewalk in front of Muzio's. Chiesa's—renamed Chiesa's Café and Oyster House—had café curtains in the windows to screen diners from passersby. (Courtesy of the Franks Collection.)

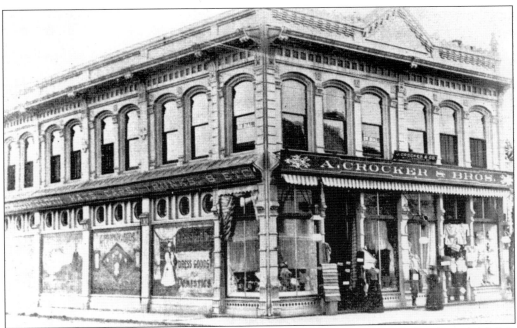

A. CROCKER & BROTHERS DEPARTMENT STORE. In 1887, brothers Aaron, Jacob, and Adolph Crocker established A. Crocker & Brothers on the southwest corner of Higuera and Garden Streets. Later referred to as "the merchandising pioneers of California," the Crocker brothers sold "piece goods"—cloth, thread, lace, and ribbon—as well as ready-to-wear clothing, trunks, suitcases, and household items. In 1920, the department store was sold to J.D. Riley, who changed the name to Riley-Crocker. The business, later renamed Riley's, moved up the street to the southeast corner of Higuera and Chorro Streets in 1955.

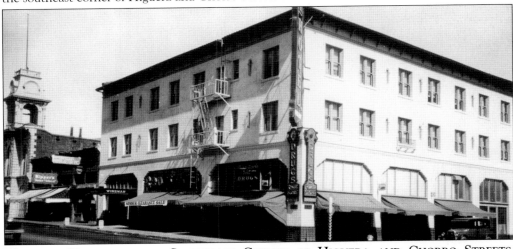

WINEMAN HOTEL, AT THE SOUTHEAST CORNER OF HIGUERA AND CHORRO STREETS, C. 1930S. When the Wineman Hotel opened on May 26, 1931, the *Telegram-Tribune* hailed the "bright, stucco, modified-Spanish design" as "ultra-modern, a monument to commerce and culture." The 50-room hotel had been built by the family of the late Central Coast rancher George Wineman. Riley's department store occupied the ground floor of the building from 1955 to 1993.

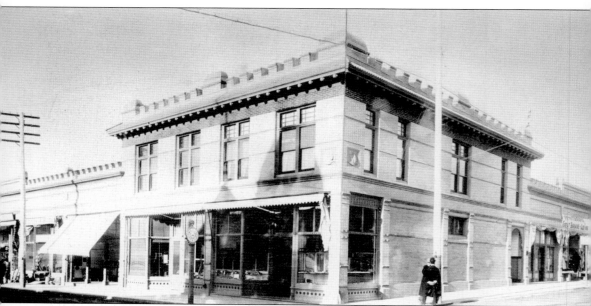

JOHNSON BLOCK, NORTHWEST CORNER OF HIGUERA AND CHORRO STREETS. Unofficially known as "La Paloma"—Spanish for "the dove"—the Johnson Block represented a variety of architectural styles. The Italianate style influenced the roof design, which had metal domes at the corners and edges of the structure. A filigree "open-mouth-carp" motif, originally used by Chinese architects to ward off evil spirits, spanned the spine of the roof. Doves were depicted in two bas-relief terra cotta tiles on the building's exterior. O'Sullivan's Shoe Palace, Marshall's Jewelry Store, and W.H. Schulze Men's Haberdashery were among the commercial building's first tenants.

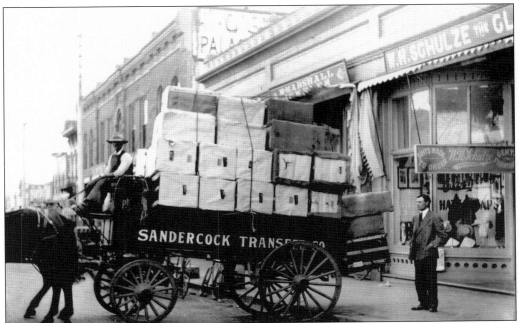

W.H. Schulze Haberdashery, 782 Higuera Street. One of the first tenants in the Johnson Block, W.H. Schulze opened its doors in 1904. For 40 years, the men's haberdashery catered to San Luis Obispo's well-dressed gentlemen with a fine selection of made-to-order suits, hats, and accessories.

Warden Building, Northeast Corner of Higuera and Chorro Streets. Built in 1904 by Los Osos Valley rancher and banker Horatio M. Warden, the richly ornamented Renaissance Revival–style Warden Building originally had a majestic 72-foot rooftop clock tower and steeple. The steeple was removed after a devastating 1925 Santa Barbara earthquake left many San Luis Obispo citizens fearful of the stability of architectural embellishments adorning many of the city's structures. By the 1950s, years of storefront remodels had compromised the structural integrity of the Warden Building and caused the magnificent clock tower to cant northward, away from Higuera Street. Deemed unsafe, the clock tower was torn down in 1955. Today, the structure is commonly referred to as the Tower Building.

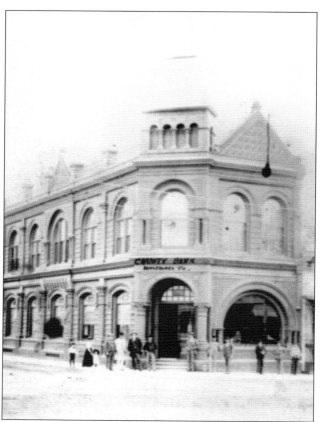

COUNTRY BANK, SOUTHWEST CORNER OF HIGUERA AND CHORRO STREETS. Constructed in 1888, the Romanesque Revival–style Country Bank of San Luis Obispo impressed early residents with its stately masonry, arched windows, short columns, Corinthian capitals, and Second Empire–style mansard roof. About 1900, the Commercial Bank took over the building.

SECURITY FIRST NATIONAL BANK, SOUTHWEST CORNER OF HIGUERA AND CHORRO STREETS. In 1919, the Commercial Bank was succeeded by Pacific Southwest Trust and Savings, which in turn gave way to the Security First National Bank, "the bank on the corner," during the 1930s and 1940s. Ross Jewelers took over the site in the late 1960s, and in the 1980s, Van Gundy & Sons jewelers. Today, the old bank is home to a lingerie store. (Courtesy of the Carpenter Collection/SLOCMHC.)

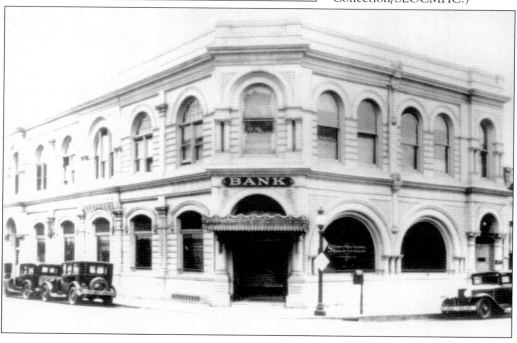

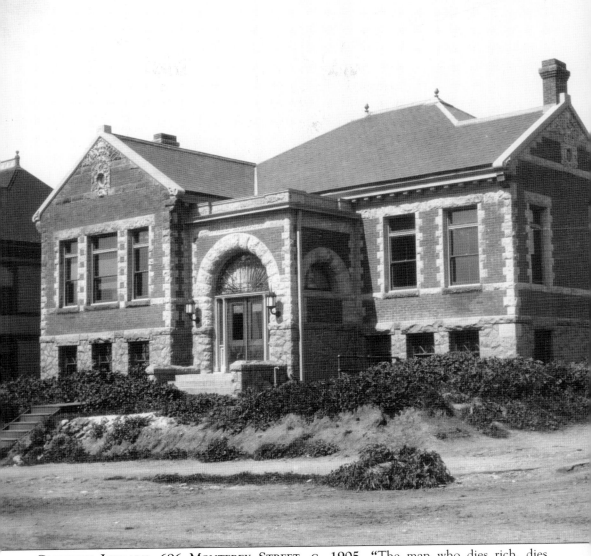

CARNEGIE LIBRARY, 696 MONTEREY STREET, C. 1905. "The man who dies rich, dies disgraced!" was the philosophy of steel tycoon and philanthropist Andrew Carnegie, who gave away most of his wealth for the betterment of mankind. Through his national foundation, which provided libraries for small towns, Carnegie donated $10,000 to construct a "free library" in San Luis Obispo. The library, built in 1905 on the northwest corner of Monterey and Broad Streets, is now home to the San Luis Obispo County Museum and History Center. The old San Luis Obispo Library was one of 2,500 free libraries funded by Carnegie. A free library was a novel concept at the beginning of the 20th century. San Luis Obispo's first public library, established in 1894 on the second floor of the J.P. Andrews Bank building, offered subscriptions to borrow books at 50¢ per month, or $50 for a lifetime membership. By the early 1900s, the small library had become overcrowded, and the desire of local citizens for the "intellectual advancement of San Luis Obispo" led them to spearhead a building effort for a new and larger library.

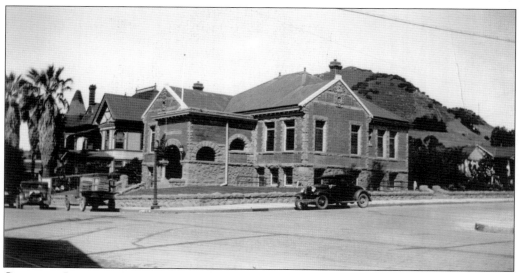

CARNEGIE LIBRARY WITH PORTICO ADDITION, C. 1936. Architect W.H. Weeks designed the Richardsonian Romanesque–style building that was constructed of red brick made at the Ah Louis Brickyard (where Foothill Boulevard is today), yellow sandstone from Los Berros near Arroyo Grande, and blue granite quarried at Bishop Peak. The gargoyle-like faces carved in the stone blocks of the eastern and southern gables signify "hospitality." The entrance portico and surrounding granite wall were added several years later. Dr. Norton's house is pictured to the left of the library.

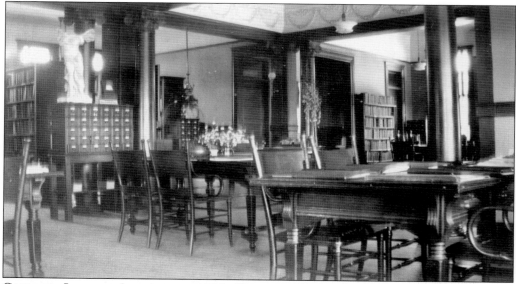

CARNEGIE LIBRARY, INTERIOR, C. 1929. Illuminated by both electric lights and gas fixtures, the high-ceilinged interior of the library was bright, spacious yet cozy, and beautifully furnished. Some of the original lights and furniture are still in use today, as is the beautifully carved, semi-circular circulation desk. The 1905 opening-day reception drew a large crowd of San Luis Obispo's most prominent citizens. Chrysanthemums, palms, ferns, and smilax decorated the main room, and several local residents played mandolins and guitars while ladies served light refreshments in the committee room.

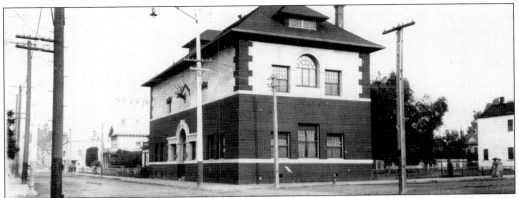

THE FIRST ELKS CLUB, C. 1906. The Elks Club of San Luis Obispo built its first lodge on the northeast corner of Marsh and Morro Streets in 1906. An elk's head, mounted high above the entrance door, graced the Morro Street façade. The structure was razed a few years later to make way for a new, more spacious Elks Club.

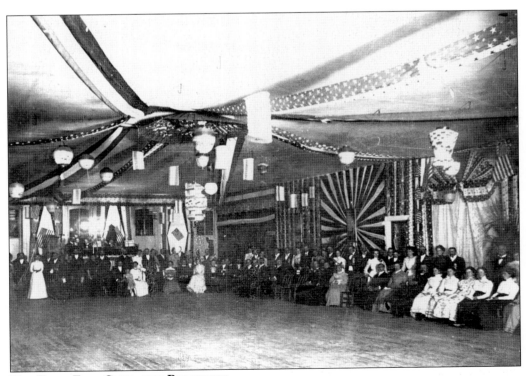

THE FIRST ELKS CLUB, THE BALLROOM.

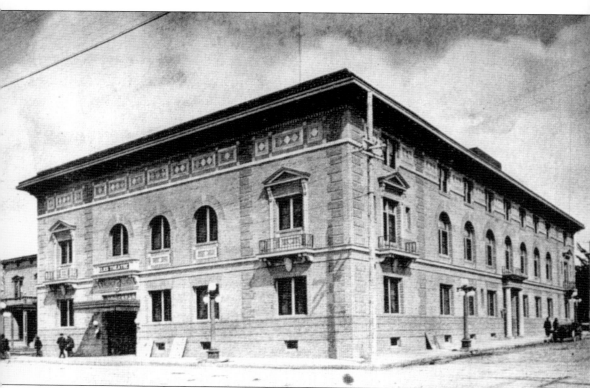

THE SECOND ELKS CLUB. The Elks Club moved into its new quarters on November 19, 1912, amid much pomp, ceremony, and celebration. The lodge, which also contained a ballroom and theater, remained home to the fraternal order for nearly half a century. The Elmo Theater attracted some of the best vaudeville acts of the day before the advent of movies and the demise of road shows. Resembling a turn-of-the-century opera house, the Elmo had carpeting, upholstered red-plush seats on the main floor, two-tiered box seats trimmed with gold piping in the "dress circle," and a balcony. The stage curtain depicted a path winding its way through stylized trees and flowers to a turreted castle. In later years the Elmo ran silent movies until the 1920s when the projectionist hung a sign on the marquee that read: "Elmo now talks." During World War II, Red Skelton gave a free, one-man show at the Elmo during his stay at nearby Camp San Luis Obispo. Dressed in his army uniform, he told family-oriented jokes, much to the delight of the audience. All proceeds from the show were donated to the local USO. The building was demolished in the late 1960s to make way for a bank. (Courtesy of the Carpenter Collection/SLOCMHC.)

CENTRAL CREAMERY, 570 HIGUERA STREET. East Coast dairyman August Jensen opened the Central Creamery in San Luis Obispo in 1910. Housed in a former garage and machine shop on Higuera Street, the creamery changed names several times through the years until Foremost Dairy bought the business in 1954. In the mid 1970s, the dairy closed and the building became a complex of shops and restaurants. In the 1990s, the San Luis Obispo Art Center took over the site.

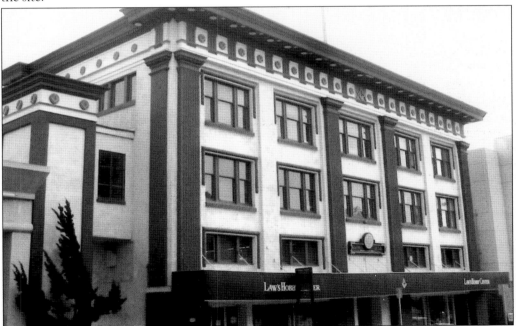

MASONIC TEMPLE, 859 MARSH STREET, 2004. The Masonic Hall Association built an enormous temple on the south side of Marsh Street in 1913. San Francisco architect John Davis Hatch designed the four-story Neo-classical Masonic Temple with a symmetrical façade and six pilasters that extended the height of the building. Retail shops were located on the ground floor and the fraternal order's meeting rooms on the upper floors. The Masonic Temple also served as a residence for its president, W.P. Adriane, a local shoe dealer. (Courtesy of the Franks Collection.)

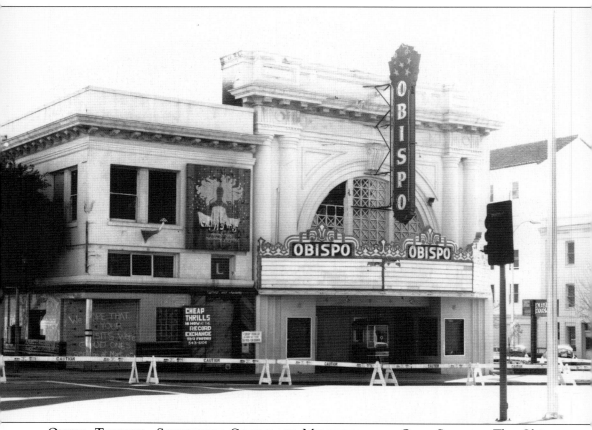

OBISPO THEATER, SOUTHWEST CORNER OF MONTEREY AND OSOS STREETS. The Obispo Theater—originally named the El Monterey—opened December 24, 1911. Guests paid 20¢ to walk through the magnificent arch-and-grill façade into the grand, two-story auditorium where they saw silent films and some of the best vaudeville acts of the day. Built to seat 1,000 people, with a large stage, orchestra pit, dressing rooms, and state-of-the-art equipment, the El Monterey was a favorite among locals as well as out-of-towners. When William P. Martin purchased the El Monterey in 1928, he changed its name to the Obispo (Spanish for "bishop"), equipped the theater for talkies, and completely remodeled the interior. The rich Wedgwood-blue décor complemented the gold mirrors and the masks of "Comedy" and "Tragedy" that hung on the walls. Two large wrought-iron, antique chandeliers and several smaller ones adorned the high ceiling. A painted mural of Morro Rock was proudly displayed above the proscenium. In the 1930s, many Hollywood celebrities attended movie premiers at the Obispo, including the Barrymore family, Charlie Chaplin, Harpo Marx, Helen Hayes, William Randolph Hearst, Marion Davies, Norma Tallmadge, and Loretta Young. The Obispo Theater burned down in 1975.

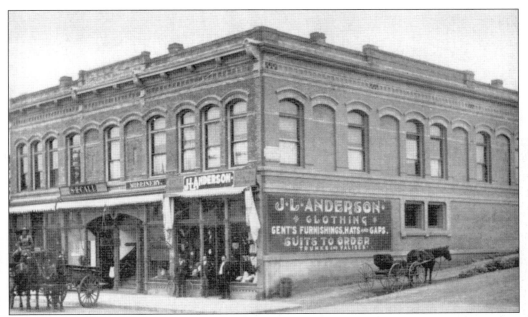

CALL BUILDING, 894 MONTEREY STREET. Jefferson Anderson operated the J.L. Anderson Clothing Company, a men's haberdashery in the Call Building on the northwest corner of Morro and Monterey Streets. In 1923, Anderson closed the store to construct the Anderson Hotel across the street.

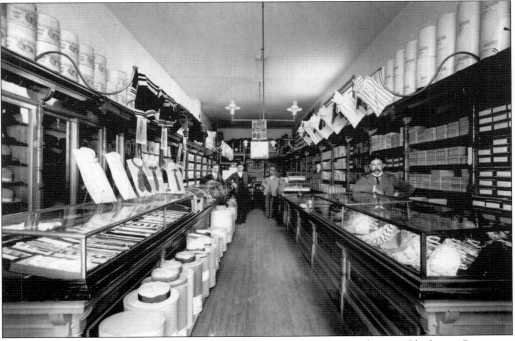

J.L. ANDERSON CLOTHING COMPANY, INTERIOR. The J.L. Anderson Clothing Company stocked men's wear as well overalls and hats for railroad workers.

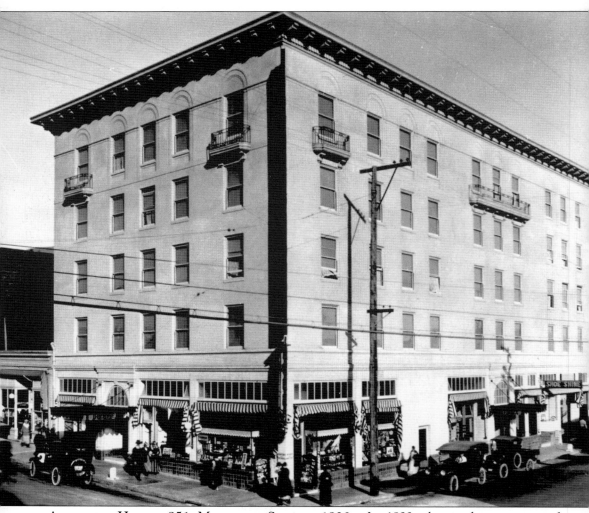

ANDERSON HOTEL, 951 MONTEREY STREET, 1920S. In 1923, the southeast corner of Monterey and Morro Streets became a popular destination for celebrated travelers with the opening of the impressive Anderson Hotel. Dignitaries and celebrities flocked to the elegant, five-story inn, where they rested in comfort and dined in grand style. The elegant California Mediterranean-style hotel with red-tile roof, plaster walls, and a charming courtyard patio boasted a cocktail lounge, first-class restaurant, drugstore, cigar store, and barbershop. Guests marveled at the telephones in every room, the exquisite marble stairway, and the hotel elevator—one of the first in town. A five-story annex, a basement, and a large Spanish-style roof tower were added in 1930. William Randolph Hearst often entertained at the fashionable hotel, where he kept an open account. Writers, newspaper columnists, and several governors numbered among his guests, in addition to his companion, Marion Davies, and celebrity friends like Charlie Chaplain, Rudolph Valentino, Clark Gable, and Jack Benny. Davies usually arrived on the evening train and had her private car pushed onto the siding at nearby Murray Street. Chauffeur Steve Zegar drove Davies and her well-known companions to the Anderson to stay overnight or have breakfast before the two-hour trip to Hearst Castle.

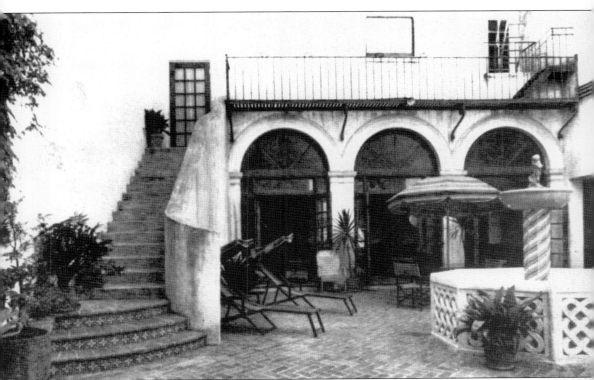

ANDERSON HOTEL, COURTYARD PATIO. In the 1950s, Tony Curtis and "sweater girl" Janet Leigh had an extended stay at the Anderson. Former hotel employees remember the night Leigh stunned unsuspecting diners with her appearance in the hotel restaurant, the Anderson Grill. Reported to be more beautiful in person than on the screen, Leigh caused the crowded, noisy dining room to fall silent as she descended the steps and entered the room. National political figures also visited the Anderson. Former First Lady Grace (Mrs. Calvin) Coolidge and her nurse once stayed for a long weekend, and President Franklin D. Roosevelt's sons stopped at the hotel while campaigning for their father.

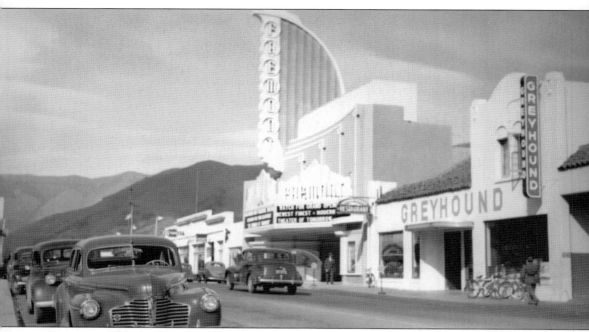

FREMONT THEATER, 1025 MONTEREY STREET, C. 1942. The 1942 Memorial Day grand opening of the heralded Fremont Theater attracted Hollywood celebrities and local residents who gathered to support our troops, watch stars Tyrone Power and Joan Fontaine in the preview screening of *This Above All*, and celebrate the birth of San Luis Obispo's "theater of tomorrow." Opening night was glamorous and exciting—San Luis Obispans crowded the streets, hoping to catch a glimpse of stars like Carol Landis, Constance Bennett, John Carroll, and Charlie Ruggles. The actors and actresses arrived by bus to sell war bonds at a rally that began in front of the courthouse across the street from the Fremont. When the rally moved to the theater, attractive, uniformed usherettes wearing wide-legged trousers and brass-buttoned jackets showed guests to their seats. The celebrities then took the stage to welcome the crowd. The Memorial Day fundraiser brought in $778,000 in bond pledges, and all theater proceeds went to the local USO. Built in 1941, the Art Deco Streamline Moderne-style Fremont Theater was designed by theater architect Charles Lee. (City of San Luis Obispo, Community Development Department.)

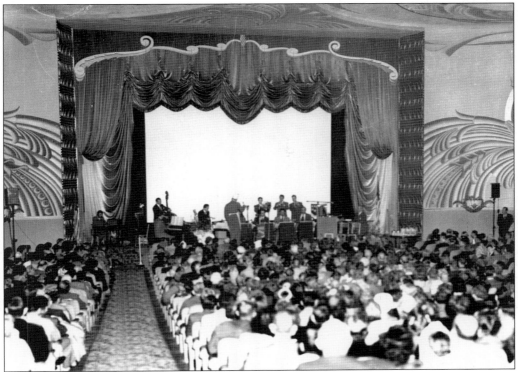

FREMONT THEATER AUDITORIUM. Inside this 1,060-seat theater, 100-foot murals covered the walls. The ceiling held ultraviolet bulbs that created a "black light" effect on the patterned carpet, which was woven with fluorescent thread. When the house lights dimmed and the ultraviolet lights were turned on, the carpet looked like a painting on glass, drawing oohs and aahs from delighted moviegoers.

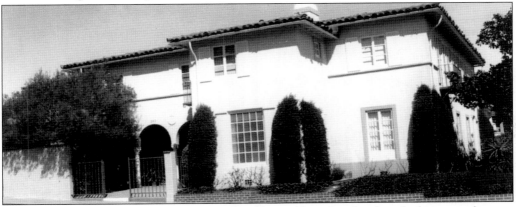

TEASS HOUSE, 890 OSOS STREET, 2004. Dr. Chester Teass lived and worked in a stately, two-story Mediterranean-style building that was constructed on the northeast corner of Palm and Osos Streets in 1929. A former army surgeon from San Francisco, Teass hired Santa Barbara architects Abrahams and Simms to design the 40- by 60-foot stuccoed structure, which had a walled-in garden and a hand-painted ceiling. Teass was instrumental in building San Luis Obispo County General Hospital in the 1930s and was William Randolph Hearst's private physician.

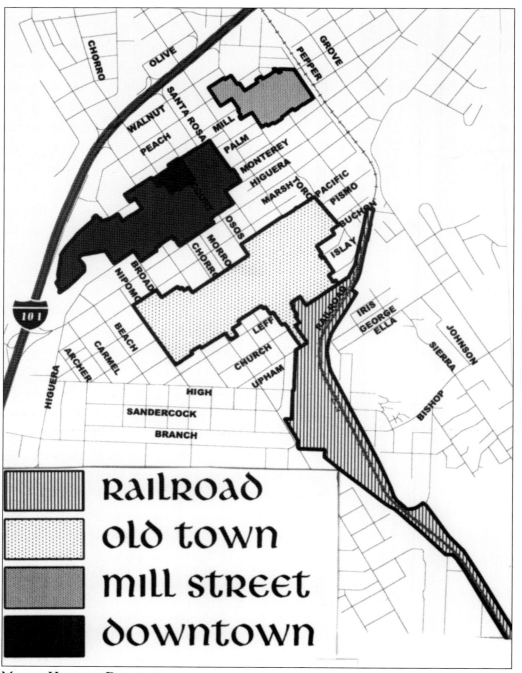

MAP OF HISTORIC DISTRICTS.

Two
RESIDENTIAL DISTRICTS

Three residential neighborhoods arose at the edges of San Luis Obispo's downtown commercial district, each area reflecting not only the social status of its residents but also their fear of flood and fire. The new housing developments were built of wood, from the milled lumber brought to San Luis Obispo from Santa Cruz and Redwood City by the Pacific Coast Railway.

South of downtown, the fashionable Murray and Church District attracted the city's prominent bankers, doctors, lawyers, political figures, and entrepreneurs who built extravagant homes. Buchon Street, San Luis Obispo's version of San Francisco's Nob Hill, became a popular address for affluent citizens because the hilltop location offered safety from flooding. Several High Victorian residences lined Buchon, while Victorian, Neo-classical, and Neo-colonial houses were built on surrounding streets. By the turn of the 19th century, the Murray and Church District had been almost fully developed, though the streets were not paved until the 1920s and 1930s. Today, the area is known as Old Town.

Several blocks south of Murray and Church, the Railroad District grew up around the Southern Pacific depot. Many railroad employees and their families lived in "Railroad Houses" and modest cottages made of pre-cut wood mail ordered from Northern California.

After Murray and Church began to grow, another upscale neighborhood developed on a hill northeast of downtown, in an area bounded by Walnut, Santa Rosa, Palm, and Pepper Streets. Known as the Mill Street District, this neighborhood offered safety from flooding *and* fire. In San Luis Obispo, fear of fire had dramatically increased after the 1906 San Francisco earthquake and fire. The new residential area was a safe distance from the downtown and other neighborhoods, and its homes had extra space between them.

The Mill Street District contained a number of period-revival homes, and in the 1920s Tudor Revivals, reminiscent of romantic medieval English and French cottages, were especially popular. During the Great Depression, the whimsy of Tudor Revival offered homeowners a sense of fantasy, an "escape from reality." Spanish-style architecture was also a favorite through the 1920s and 1930s, with Contemporary Clapboard emerging in the 1940s.

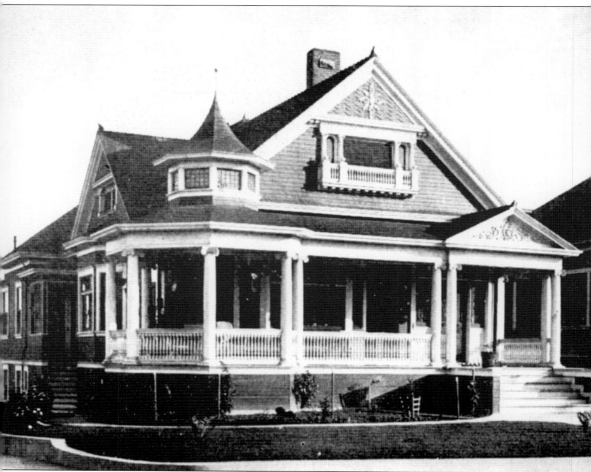

CROCKER HOUSE, 793 BUCHON STREET. In 1901, influential businessman and merchant Jacob Crocker built a Classic Revival/Queen Anne home a few blocks from his successful downtown department store, Crocker Brothers. Renowned California architect William Weeks designed the richly ornamented home with an unusual tower, a front gable, and a wide veranda with spindled railing that spanned the width of the façade. The Crocker House stands today as one of the few historic residences in the city designed by a professionally trained architect.

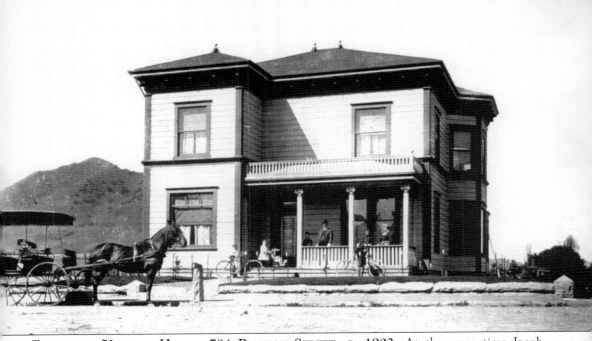

FITZGERALD/KIMBALL HOUSE, 794 BUCHON STREET, C. 1902. At the same time Jacob Crocker was building his home in 1901, A.F. Fitzgerald built a two-story Italianate home across the street on the northwest corner of Buchon and Chorro. Fitzgerald owned several successful downtown businesses, served as the president of the chamber of commerce, and helped found California Polytechnic School (later to become California Polytechnic State University) in San Luis Obispo. In later years, Mayor Fred Kimball—who defeated longstanding Mayor Louis Sinsheimer—lived here. (Courtesy of the Swift Collection.)

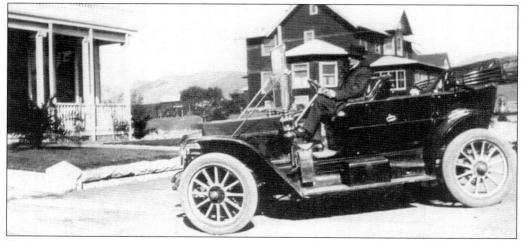

THOMAS NORTON HOUSE, 850 BUCHON STREET, C. 1906. In 1906, Pacific Coast Railway superintendent E.W. Clark built the largest home in the city at that time. He chose a site across the street from the Kimball House, on the northeast corner of Buchon and Chorro. Known as Greystone, Clark's house (seen behind the man in the automobile) stood on a hillside with a commanding view of the city. The Neo-colonial/Craftsman, ten-room, "ultra-modern" residence had an unusually large parlor and a retaining wall of gray granite quarried at Bishop Peak. When Clark and his wife moved to Los Angeles in 1914, Mayor Thomas Norton purchased the home fully furnished. (Courtesy of the Swift Collection.)

MARSHALL HOME, 785 BUCHON STREET, 1904. Manuel Marshall, the proprietor of Marshall's Jewelry Store, constructed this modest yet attractive residence in the late 1890s. The home's simple Neo-colonial/Neo-classical style reflected changing architectural trends at the turn of the 20th century that moved away from elaborate Victorian designs. The home still contained Queen Anne overtones, however, with an intricate bas-relief motif over the windows that suggested—rather than boasted—the prosperity of the homeowner. In 1955, the Marshalls sold the home to Eugenia and Harry Dixon, the owners of Dixon Plumbing on Orcutt Road. The Dixons lived in the house for nearly 25 years.

COWDERY HOUSE, 880 BUCHON STREET, 1904.

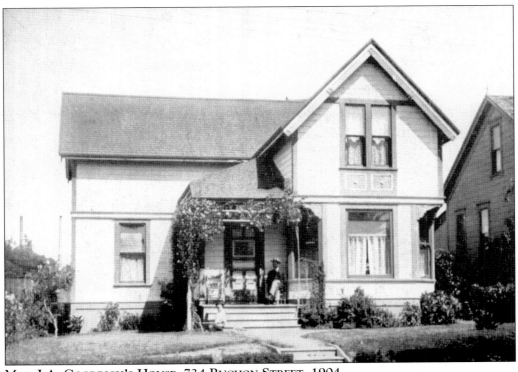

MRS. J.A. GOODRICH'S HOUSE, 734 BUCHON STREET, 1904.

BRADBURY HOUSE, 745 BUCHON STREET, 2004. Dr. Richard M. Bradbury, one of the city's most prominent physicians, built this one-story, wood-frame, Neo-classic "row house" (precursor of the modern tract house) on Buchon Street in 1910. The fashionable home symbolized the aspirations and values of the professional class in San Luis Obispo that emerged after the arrival of the Southern Pacific Railroad. Two years later, Dr. Bradbury constructed a sanitarium on the adjacent lot. (Courtesy of the Franks Collection.)

BRADBURY SANITARIUM, 743 BUCHON STREET, 2004. The Bradbury Sanitarium, constructed c. 1912, stood next door to Dr. Richard Bradbury's home as one of the city's first hospitals. Later known as the Pacific Hospital, the medical facility regularly advertised in the *San Luis Obispo Tribune* as "a modern hospital, ideally situated on high ground, modern in every respect and equipped in every detail of the scientific care of the sick [A]ll nurses are strictly graduates from the finest institutions in America." (Courtesy of the Franks Collection.)

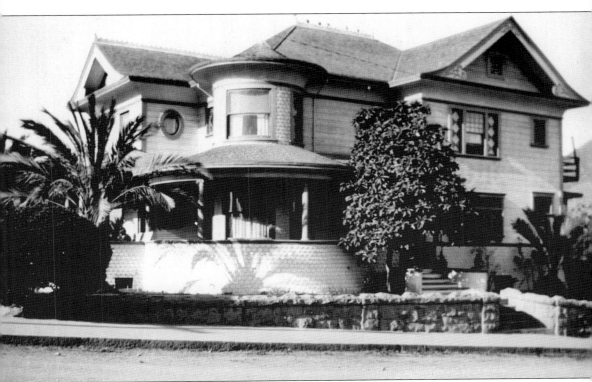

STANTON/LEWIN HOUSE, 752 BUCHON STREET. Edward Stanton, an officer of the narrow-gauge Pacific Coast Railroad, constructed this *c.* 1905 family home on the northwest corner of Buchon and Garden Streets. Stanton's wife, Irene Josephine Dana, was a daughter of Capt. Charles William Dana, an early San Luis Obispo pioneer and the city's mayor from 1881 to 1882. The Stantons' unique home featured a bellcast roof, circular turrets, a wrap-around porch, and a variety of windows, some with stained glass.

MYRON ANGEL HOUSE, 714 BUCHON STREET. Well-known journalist and historian Myron Angel purchased this three-story, wood-frame residence on the corner of Broad and Buchon Streets in 1896. The late 1880s Victorian-style American farmhouse reflected homes of the rural Midwest and antebellum South. Angel worked as an editor at the *San Luis Obispo Tribune*, wrote the 1883 *History of San Luis Obispo County*, and played an integral part in the founding of California Polytechnic School, today California Polytechnic State University (see page 118).

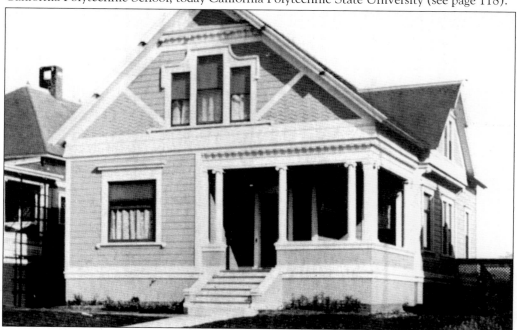

TROUSDALE HOUSE, 779 BUCHON STREET, 1904. In 1902, H. S. Trousdale, a brakeman for the Pacific Coast Railroad, and his wife constructed this Carpenter Gothic Revival–style home. Later, the residence became the home of W.A. Rideout and his wife, Mary, who was the daughter of prominent 19th-century businessman J.P. Andrews. At age 90, Andrews came to live here with his daughter and son-in-law until his death in January 1914. Andrews, who built the downtown landmark Andrews Bank building, had lived most of his adult life with his family in an old adobe on Andrews Street.

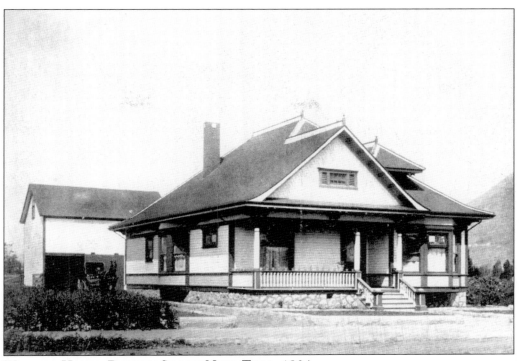

WALLACE HOUSE, BUCHON STREET NEAR TORO, 1904.

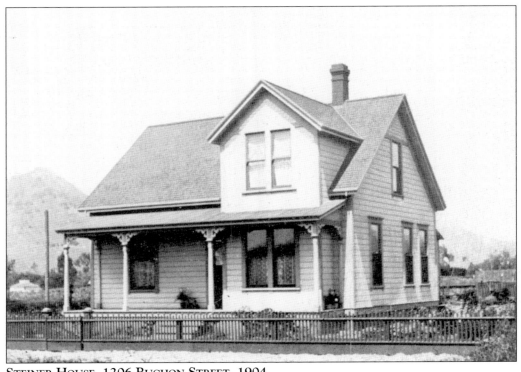

STEINER HOUSE, 1206 BUCHON STREET, 1904.

73

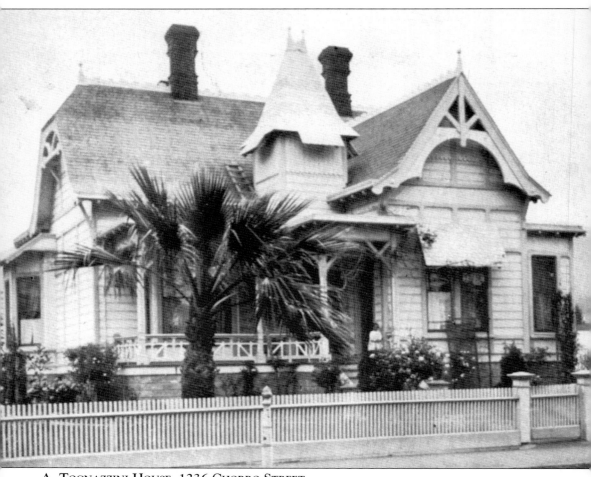

A. Tognazzini House, 1236 Chorro Street.

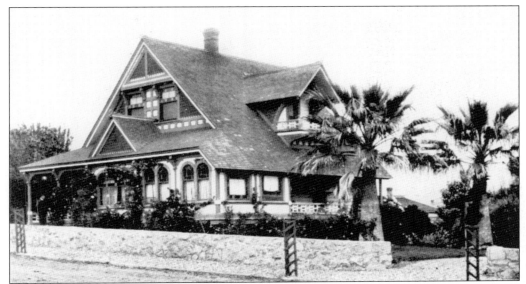

BENJAMIN BROOKS HOUSE, 1518 CHORRO, C. 1904. Benjamin Brooks was a highly esteemed journalist and editor of the *San Luis Obispo Tribune* who lived in this Eastern Shingle/Colonial Revival house on Chorro Street. Significantly altered from its original style, the two-story house had a large backyard planted with many trees. This historic home also served as a location for the 1990 film *My Blue Heaven*, starring Steve Martin.

MAZZA HOUSE, 1318 CHORRO STREET. Mazza House is one of four buildings in San Luis Obispo constructed of granite quarried at Bishop Peak. Pioneer veterinary surgeon Dr. Dock B. Mazza built the Neo-classical row house as a residence several blocks from his Higuera Street office *c.* 1906.

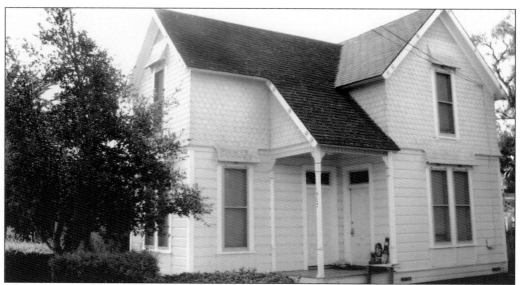

HOURIAN HOUSE, 1907 CHORRO STREET, 2004. Arroyo Grande ranchers Thomas and Kate Hourian resided part time in what is believed to be a "half house" on Chorro Street. It was a common practice in the 1880s and 1890s to saw farmhouses down the middle and transport them to the city, where they were renovated as town homes. The Hourian House bears a striking resemblance to the house at 497 Islay Street, where the Hourians also lived at one time. It is possible that both homes were at one time joined as one structure. (Courtesy of the Franks Collection.)

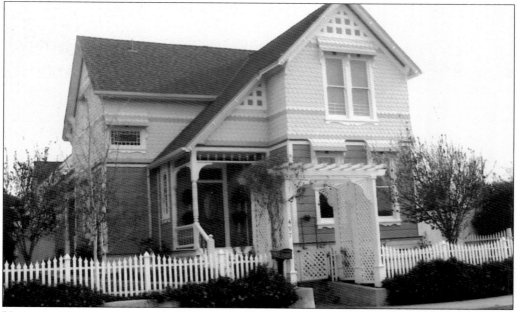

VOLLMER HOUSE, 497 ISLAY STREET, 2004. The Vollmer House is believed to be a "half house," once joined to the Hourian House (shown above) at 1907 Chorro Street. This Eastern Shingle-style home with Queen Anne motifs features bellcast eaves above all the windows. (Courtesy of the Franks Collection.)

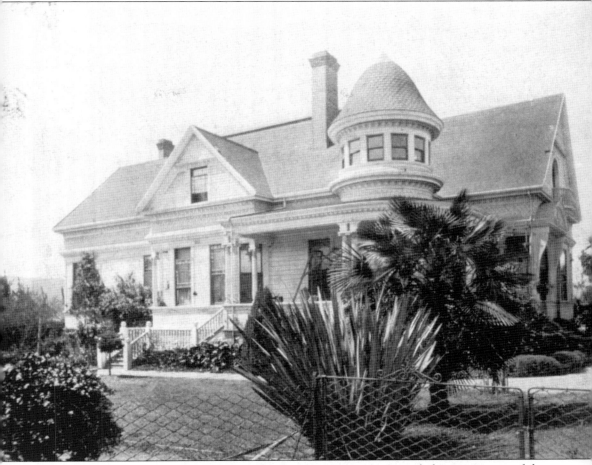

ERICKSON HOUSE, 687 ISLAY STREET. This massive Queen Anne–style home was one of the most architecturally impressive residences in the city at the turn of the 20th century. Built in the mid-1890s for Southern Pacific Railroad contractor Charles Erickson and his family, the house had a turret and a heavily ornamented pediment with "fish-scale" shingles, turned wood, and a "keyhole" balcony. Erickson played a major role in building the Southern Pacific Railroad tunnels that ran through the Santa Lucia Mountains along the Cuesta Grade.

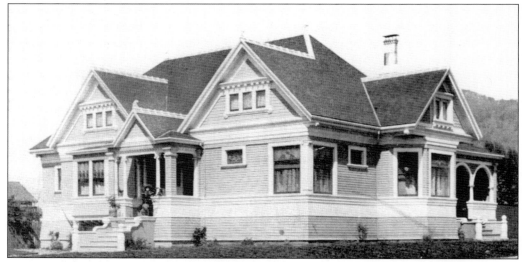

WILLARD KIMBALL HOUSE, 690 ISLAY STREET, 1904. In 1902, attorney Willard Kimball and his wife, Carrie, constructed a Colonial Revival home at the southwest corner of Islay and Broad Streets. Kimball helped establish the San Luis Obispo Street Railway, the city's horse-drawn streetcar system used in the late 19th century.

WILLETT HOUSE, 670 ISLAY STREET, 2004. The Willett House stood as a prime example of a "railroad house," one of the many simple, unadorned, one-story, wood-frame homes built for railroad employees in the 1880s. These dwellings may have been pre-fabricated houses put together with ready-made parts and wood siding mail ordered from a company in Northern California. Congregational Church Rev. George Willett and his wife lived in the Islay Street home in 1904. (Courtesy of the Franks Collection.)

BAUMAN HOUSE, 1160 ISLAY STREET, 1904.

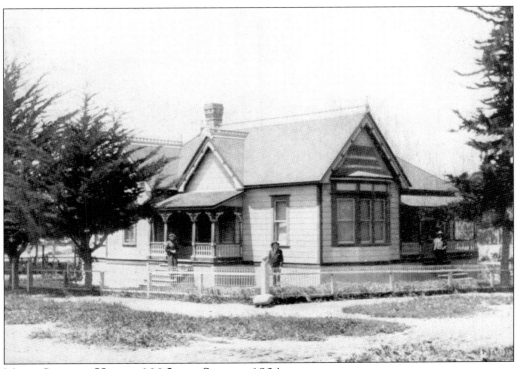

MARY GRAHAM HOUSE, 390 ISLAY STREET, 1904.

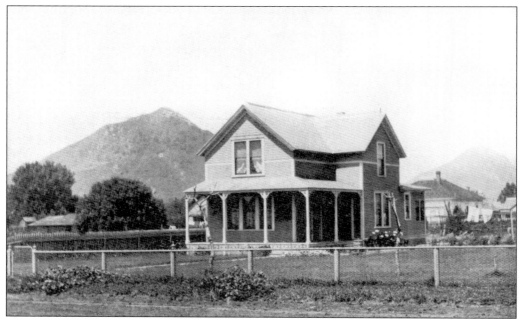

LEAVITT HOUSE, 1060 ISLAY STREET, 1904.

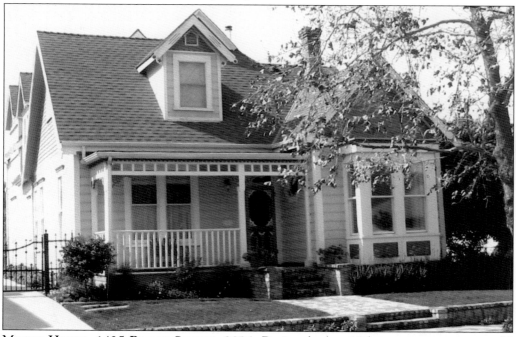

MILLER HOUSE, 1435 BROAD STREET, 2004. During the late 19th century, many successful ranchers and farmers built townhouses in the city. In 1896, Alice Miller, the wife of a prominent cattle rancher, built a townhouse on Broad Street on a lot she purchased for $10. The lot, formerly occupied by part of the San Luis Feed Lot and Corral, was assessed at $155, with improvements worth $750 soon after the home was built. (Courtesy of the Franks Collection.)

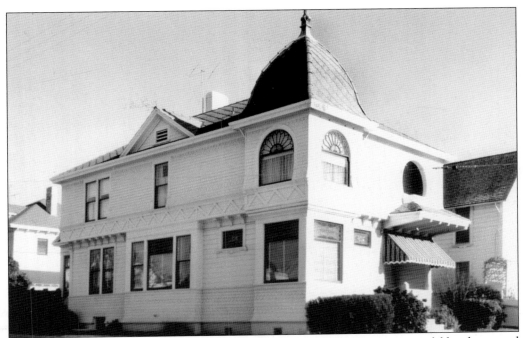

VETTERLINE HOUSE, 1504 BROAD STREET, 1960. Frank Vetterline, a successful hardware and plumbing merchant, built a large, elaborate, Queen Anne–style two-story home at the corner of Broad and Buchon Streets c. 1896. The home had a distinctive look, with a bellcast roof on a corner turret and a round, cut-out, semi-enclosed balcony. Vetterline served on the San Luis Obispo Board of Trustees and as a county supervisor in 1909.

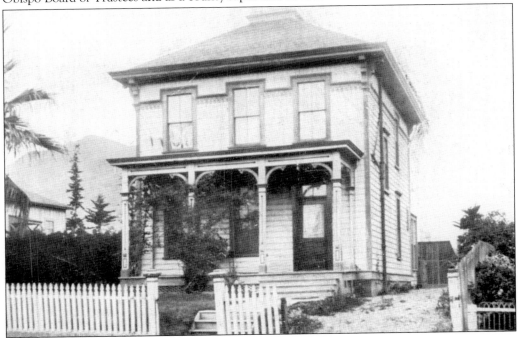

FINNEY HOUSE, 670 PISMO STREET, 1904.

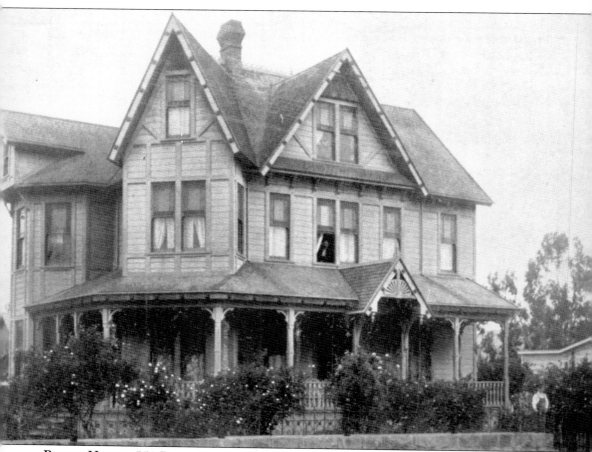

BIDDLE HOUSE, 559 PISMO STREET. The Biddle House represented Eastern Stick architecture at it finest. Influenced by a variety of styles, the three-story, 4,000-square-foot residence had a Queen Anne spindled porch and Eastern Stick and Carpenter Gothic details. Four fireplaces heated the home, the one in the parlor incorporating tile and elaborately carved wood into the mantle design. All the wood doors were carved with an intricate pattern replicated in the stained-glass window frames. Elizabeth Biddle, the widow of prosperous rancher John Biddle, constructed the house for herself and her four children between 1893 and 1897. The Biddle family occupied the house for more than half a century and then rented it out for a number of years. In the late 1980s, a partnership bought the century-old property, subdivided it, and resold the residence to a private owner, who restored it to its former glory.

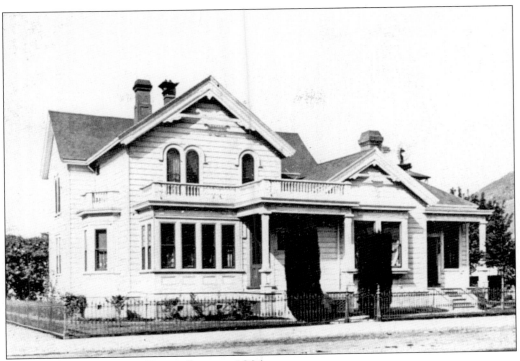

CALLENDER HOUSE, 969 PISMO STREET, 1904.

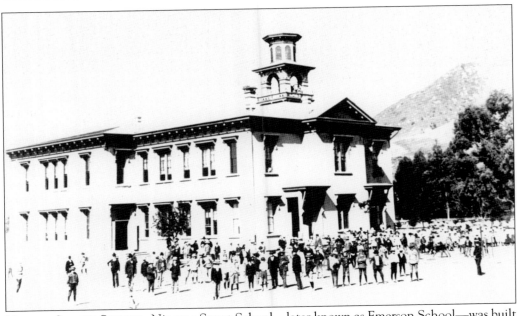

NIPOMO STREET SCHOOL. Nipomo Street School—later known as Emerson School—was built in 1886 as one of the city's first public elementary schools. The two-story brick schoolhouse, which had a bell tower on the roof, stood in the center of a spacious park-like setting, surrounded by numerous trees, shrubs, and walkways. The structure was demolished after World War II.

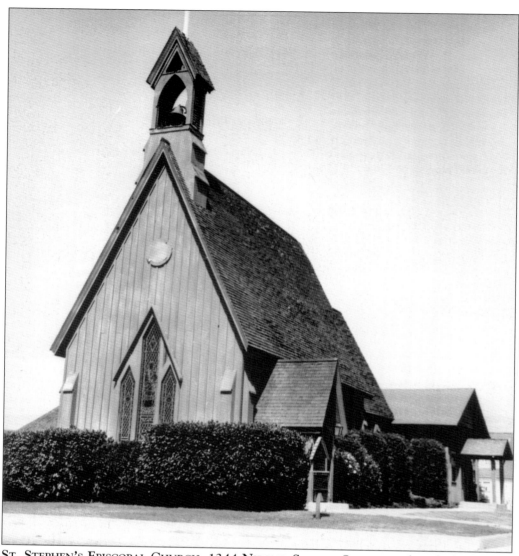

ST. STEPHEN'S EPISCOPAL CHURCH, 1344 NIPOMO STREET. Sometimes described as a "very elegant pigeon house," St. Stephen's Episcopal Church stands as an example of Gothic Revival architecture with its steeply pitched roof, multiple gables, and triangular, stained-glass windows. The first Episcopal church in San Luis Obispo, as well as one of the first in California, the architecturally distinguished St. Stephen's was built *c.* 1873. Dr. William Hays founded St. Stephen's in 1867. (Courtesy of the Carpenter Collection/SLOCMHC.)

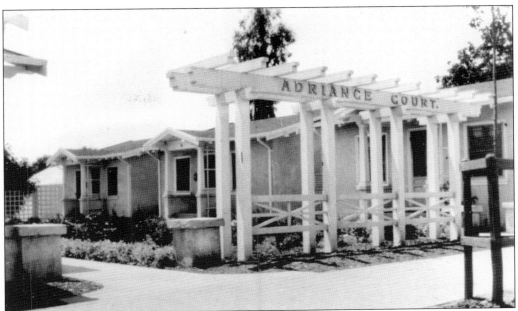

ADRIANCE COURT, 1531 SANTA ROSA STREET. Built in the late teens or early 1920s, Adriance Court consists of nine small, identical bungalows that face a central courtyard. This Craftsman bungalow complex is typical of California-style multiple residences that became popular during that era.

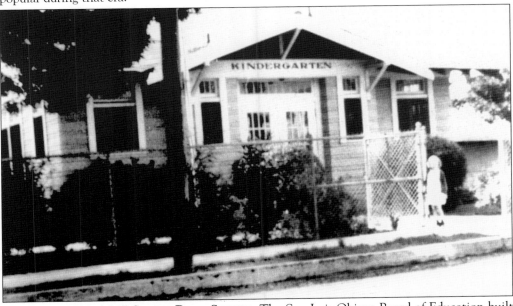

KINDERGARTEN, 1445 SANTA ROSA STREET. The San Luis Obispo Board of Education built this one-story, Craftsman cottage as a kindergarten in 1917. The late Frank Mitchell, a county supervisor, had donated the land for the building with the stipulation that it be used only for a pre-elementary school. Architect Orville Clark designed the structure, which local contractor H.E. Lyman built for about $2,500. Ironically, the kindergarten became a senior citizens' center in the 1970s.

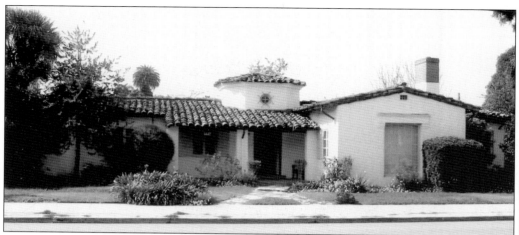

AVILA HOUSE, 1443 OSOS STREET, 2004. Manuel Avila, a successful dairyman and farmer, hired Santa Barbara architect Edward Abrahams to design a family home on Osos Street in the late 1920s. One of the few architect-designed houses in San Luis Obispo during that era, the one-story house had an octagonal room projection with a porthole that extended from the roof. It is believed that the prototype for the home came from the Chilean countryside, where Abrahams traveled while on break from the University of Southern California's school of architecture. (Courtesy of the Franks Collection.)

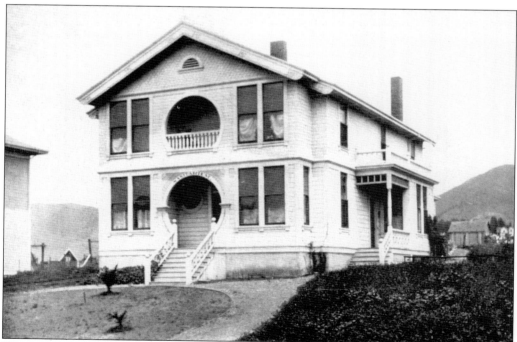

HAGEMAN SANITARIUM, 1716 OSOS STREET. This large, Neo-colonial structure on Osos Street was built as the Hageman Sanitarium in the 1880s. Constructed for machinist J.C. Waterbury and his wife, a nurse who worked there, the hospital had unusual semi-circular archways on the front porch and second-story balcony. The sanitarium became a private residence in 1912 and, during World War I, a boarding house for young women.

86

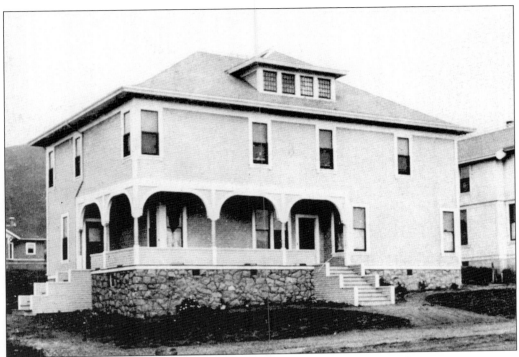

MRS. JAMES REIDY'S HOUSE, CORNER OF OSOS AND LEFF STREETS, 1904.

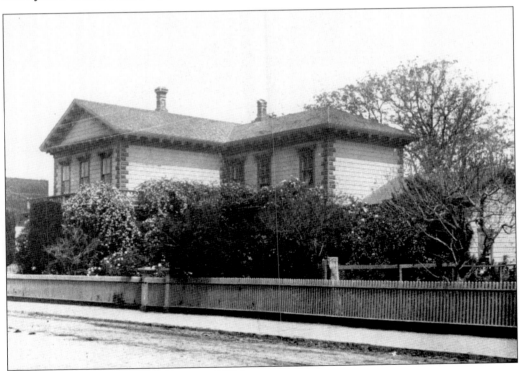

CALL HOUSE, 1104 MORRO STREET, 1904.

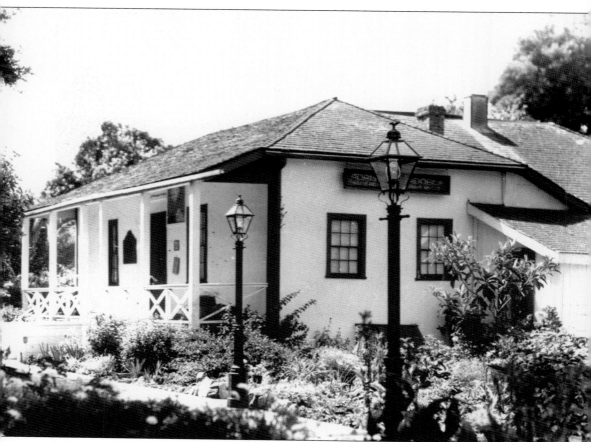

DALLIDET ADOBE, 1185 PACIFIC STREET. French immigrant Pierre Hyppolite Dallidet arrived in San Luis Obispo in the mid-1850s. He rented a room in the home of Gabriel Salazar, who owned a large tract of land surrounding the present-day site of the Dallidet Adobe. When Dallidet married Salazar's youngest daughter, Ascension, in 1859, he purchased the 16-acre property, where he built an adobe house. The Dallidets raised their large family in the three-room home, with the boys sleeping in a garret above the main room. In the late 1860s, Dallidet built a wooden addition that included bedrooms for the boys, a dining room, and an area that today is the caretaker's quarters. With his sons' help, Dallidet planted 16 acres of vineyards and constructed a winery—where a rose garden grows today—and a wine cellar beneath the house. A pioneer of the San Luis Obispo commercial wine industry, Dallidet made wine and brandy, operating the only registered distillery in the county during that time. The Dallidet family lived in the adobe until 1958, when the youngest of the Dallidets' children passed away. Today, the San Luis Obispo County Museum and History Center owns the historic adobe and gardens.

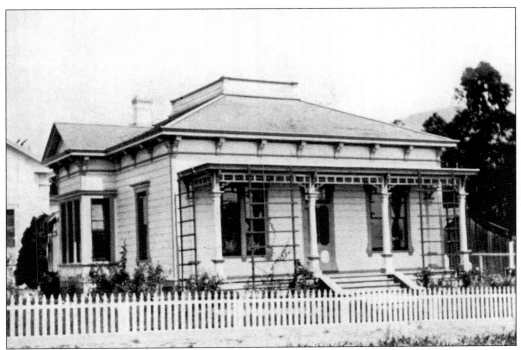

MRS. V.L. LATIMER'S HOUSE, 858 TORO STREET, 1904.

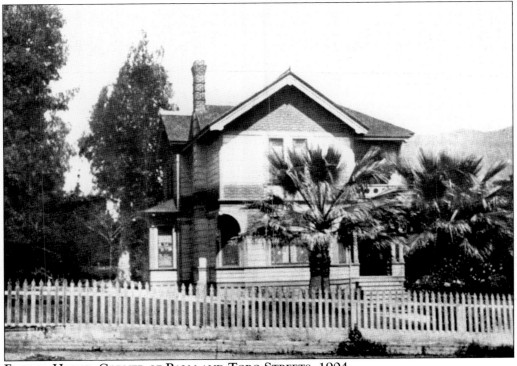

FIELDER HOUSE, CORNER OF PALM AND TORO STREETS, 1904.

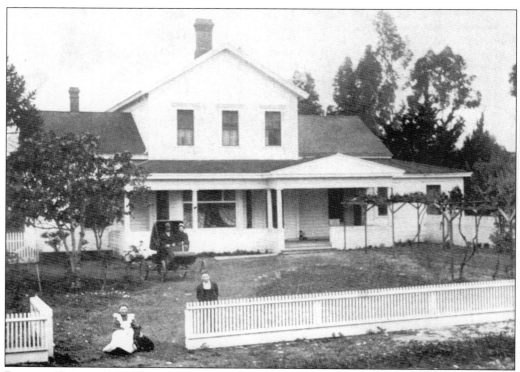

BOOKER HOUSE, 1326 HIGUERA STREET, 1904.

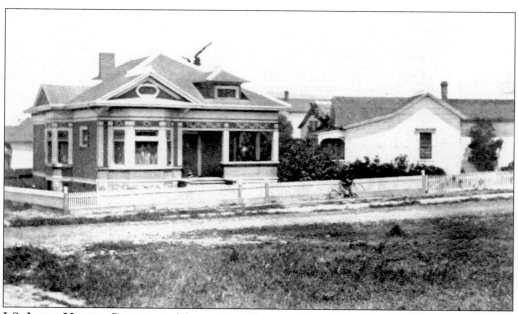

J.S. JONES HOUSE, CORNER OF MARSH AND CHURCH STREETS, 1904.

Page House, 1220 Marsh Street, 1904.

Lind/Riley House, 1306 Mill Street, 2004. The Lind/Riley House represents an outstanding example of an Eastern Shingle-style cottage. Eastern Shingle architecture served as a transitional phase between the Victorian and Neo-colonial styles in the early 20th century. Built in 1905, this home belonged in 1914 to Caroline and Jean Lind, proprietors of a downtown stationery/bookstore. J.D. Riley, the owner of Riley's department store, lived in the Mill Street home from 1916 until his death in 1945. (Courtesy of the Franks Collection.)

H. JONES HOUSE, 1330 MILL STREET, 2004. A European heritage is evident in this Craftsman-style bungalow, built as a single-family residence on Mill Street *c.* 1905. The Alpine-style, second-story balcony with carved wooden railing and the twin wooden benches on the recessed front porch reflect the Swiss ancestry of many San Luis Obispo families. Dr. Harrison Jones, a Higuera Street physician, lived in the house with his wife, Grace, from 1912 to 1918. Later, the home was converted to an apartment building. (Courtesy of the Franks Collection.)

MAINO HOUSE, 1424 MILL STREET, 2004. Three generations of San Luis Obispo's Maino family, who pioneered the local construction industry, have lived in this two-story, Mediterranean-style home. Designed by the Santa Barbara architectural firm of Abrahams and Simms, the home was built on the site of an earlier residence. (Courtesy of the Franks Collection.)

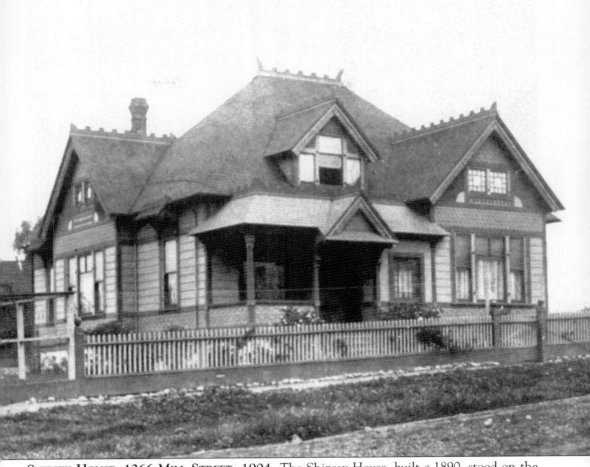

SHIPSEY HOUSE, 1266 MILL STREET, 1904. The Shipsey House, built *c.*1890, stood on the corner of Johnson and Mill Streets as a vernacular version of Eastern Stick-style architecture with its massive, mansard-like roof and large, pronounced dormers. William Shipsey worked as an attorney and notary at his office in the Andrews Bank building. Shipsey became mayor in 1900 and president of the public library in 1912.

MUGLER HOUSE, 1460 MILL STREET, 2004. Dr. Fred R. Mugler built a stately Tudor Revival residence on Mill Street in 1925, when Period Revival architecture became popular among San Luis Obispo's affluent professionals. Dr. Mugler practiced general medicine, treating patients with a wide spectrum of medical problems. He kept a variety of "modern" drugs in his medical bag, including sugar pills in four colors that he used as placebos. (Courtesy of the Franks Collection.)

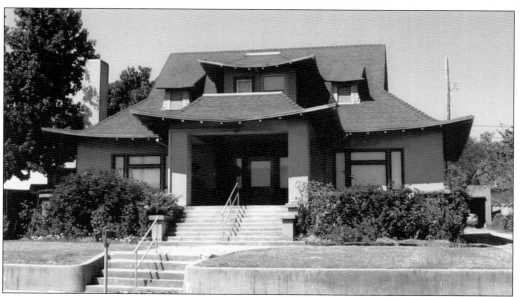

PAGODA HOUSE, 1144 PALM STREET, 2004. The Pagoda House was designed by San Francisco architect Charles McKenzie for attorney Howard Payne and his wife, Lydia. Built in 1913, the home's dramatic Chinese motif was inspired by the Paynes' trip to China in 1900. The unique residence features a bellcast roof with turned-up eaves. (Courtesy of the Franks Collection.)

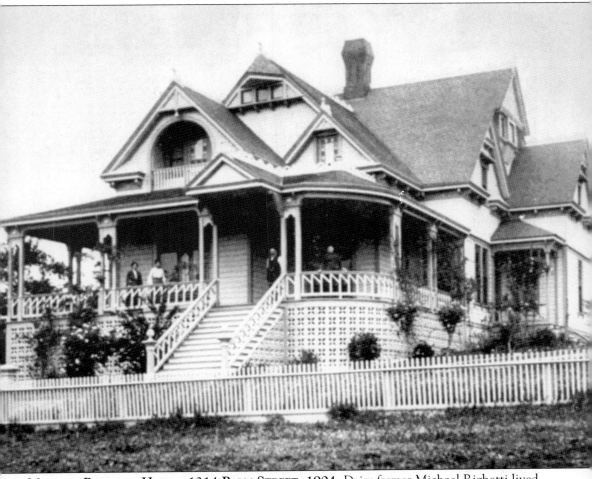

MICHAEL RIGHETTI HOUSE, 1314 PALM STREET, 1904. Dairy farmer Michael Righetti lived in this majestic, Queen Anne–style home with his wife and two daughters. Built in 1887, the large, two-story house was richly detailed with appliqués, ornaments, two verandas, and multiple gables. The home was later sold and divided into apartments.

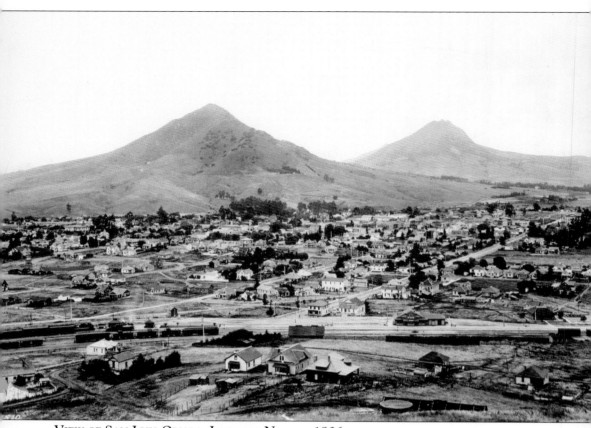

VIEW OF SAN LUIS OBISPO, LOOKING NORTH, 1906.

Three

THE CITY EXPANDS
ITS BORDERS

As San Luis Obispo's population grew, many architecturally impressive structures rose on the outskirts of the downtown and residential districts, along the entrance roads to the city, and in the open spaces of farms and ranches.

The arrival of the Pacific Coast and Southern Pacific railroads transformed the small mission town into a thriving city. Both railroads maintained division headquarters in San Luis Obispo, and rail employees stimulated home, business, and civic construction. The California Polytechnic School—which became California Polytechnic State College in 1949 and California Polytechnic State University in 1972 and became known as Cal Poly—opened in 1903. Between 1902 and 1904, approximately 200 houses were built as turn-of-the-century trends began to reflect the end of the Victorian era. Designs became less ostentatious with the Craftsman movement and a series of period revivals.

In the 1920s, earnings from the World War I "Bean Boom" and matured war bonds created money for land acquisition and construction. The Depression brought a halt to expansion, but World War II and the establishment of nearby Camp San Luis spurred new growth. Families of soldiers took up residence in town, and after the war many Camp San Luis soldiers returned to make permanent homes. During the 1940s and 1950s, San Luis Obispo County's population nearly doubled—from 33,246 to 51,417—and residential and commercial construction developed large tracts of land on the edges of the city.

Increased enrollment at Cal Poly also created growth, as did the 1954 opening of the California Men's Colony, a low-security state prison west of the city that brought a large workforce to San Luis Obispo. (These new jobs came as diesel replaced steam on the Southern Pacific Railroad—300 workers were laid off at the roundhouse in 1956.)

Today one expanse of surrounding countryside remains largely rural. To the south of town lies the Edna Valley, which until the modern era was farm and ranch land scattered with farmhouses. The Steele brothers, pioneering dairy farmers, first settled the area in the post-drought period of the late 1860s. In the 19th and early 20th centuries, several distinctive period schoolhouses were constructed for the children of farmers and ranchers. One of these, the Independence School, has been preserved as a wine-tasting room in this valley now internationally known for its vineyards and the production of fine wines.

ANDERSON HOUSE, 532 DANA STREET, 2004. This Dana Street residence was home to Anderson Hotel proprietor Jefferson Anderson and his family from the early 1900s to *c.* 1960. The Queen Anne–style house had a wrap-around porch and a beautiful backyard garden planted with orange trees. Jefferson's wife, Margaret, an expert horticulturist, kept the Anderson Hotel lobby filled with bouquets of fresh-cut flowers. (Courtesy of the Franks Collection.)

HARMONY CREAMERY, 991 NIPOMO STREET. The Harmony Creamery opened in the late 1920s on the northwest corner of Nipomo and Dana Streets. One of several in the city, the creamery supported San Luis Obispo's prosperous dairy industry. The structure stood on the former site of an old adobe where the Overland Stagecoach Company made regular stops during the 1860s. In 1970, the Reis Family purchased the property and converted the creamery building into a funeral home. (Courtesy of the Franks Collection.)

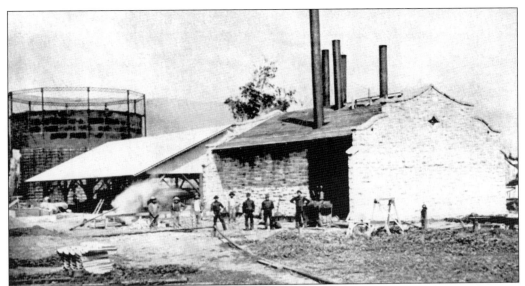

SAN LUIS GAS AND ELECTRIC WORKS, 280 PISMO STREET. Constructed *c.* 1902, the San Luis Obispo Gas and Electric Works is reputed to have been made from native sandstone quarried at the Los Berros area of Arroyo Grande. Prominent merchant Louis Sinsheimer, who became San Luis Obispo mayor in 1919, owned the company, which provided gas and electricity to the city from the early 1900s to the 1940s. Boys on bicycles, carrying long rods, turned on the gas-lit street lamps at dusk and turned them off at dawn.

SAN LUIS GAS AND ELECTRIC WORKS, INTERIOR.

HERRERA HOUSE, ARMISTICE DAY, NOVEMBER 11, 1919. Moved twice during its nearly 100-year lifetime, the Herrera family home originally stood on the present site of the county courthouse annex at 1066 Monterey Street. In 1921, the house was moved around the corner to 977 Santa Rosa Street, where it became the Bachelor's Club, a boarding house for men. (Courtesy of the Adrian Collection.)

HERRERA HOUSE, MOVING DAY, 1981. On October 29, 1981, the Herrera home was moved once again to make way for a new county parking lot. The former Bachelor's Club was relocated this time to 978 Olive Street, where it became the Heritage Inn, a bed-and-breakfast. (Courtesy of the Adrian Collection.)

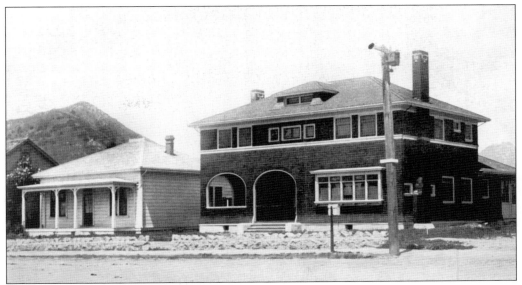

THE FIRST STOVER'S SANITARIUM AND DR. W. M. STOVER'S RESIDENCE, 1160 AND 1190 MARSH STREET. In the early 1900s, surgeon W.M. Stover built a sanitarium (at left) next door to his home (at right) on the northwest corner of Marsh and Toro Streets. One of two leading physicians in the county, Dr. Stover cared for the sick in his modest hospital until 1911, when it was torn down to make way for a new, larger facility. Dr. Stover and his wife lived in the corner home until 1924.

FRENCH HOSPITAL, 1160 MARSH STREET. The first Stover's Sanitarium was replaced with an elaborate Classic and Renaissance-Revival hospital designed by well-known architect William Weeks. The two-story, brick-veneered building had a decorative cornice with detailed brackets and dentils and a large basement, but no elevator. Attendants and nurses wheeled patients up and down ramps between the three floors. Stover's Sanitarium became San Luis Sanitarium in 1914 and French Hospital in the late 1940s.

Brown House, 530 Marsh Street, 1904.

San Luis Obispo County Hospital and Farm, Johnson Avenue. The San Luis Obispo County Hospital and Farm opened its doors February 14, 1879. Located on a hill near present-day Johnson Avenue, the site was chosen for its proximity to the "thermal belt," an inland area beyond the coastal fog where indigent patients could grow their own food. The property had a year-round spring that provided water for both hospital and garden use. Dr. William Hays was instrumental in setting up the 52-bed medical facility, which later became San Luis Obispo General Hospital.

Unangst House, 1720 Johnson Avenue. In 1892, Attorney Edwin Unangst moved with his wife, Anita Murray (the daughter of Judge Walter Murray), and their three children to a large, newly constructed home on what is now Johnson Avenue. The six-room house was a blending of styles, with a Victorian-Eastern-Shingle-style gambrel roof and a pair of Classical Revival columns flanking the front porch. A large fireplace that Unangst built of local stone dominated the study. Unangst became San Luis Obispo's mayor in the late 1890s and a superior court judge in the early 1900s.

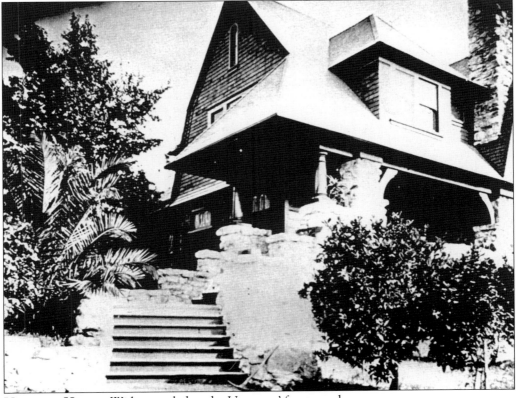

Unangst House. Wide steps led to the Unangsts' front porch.

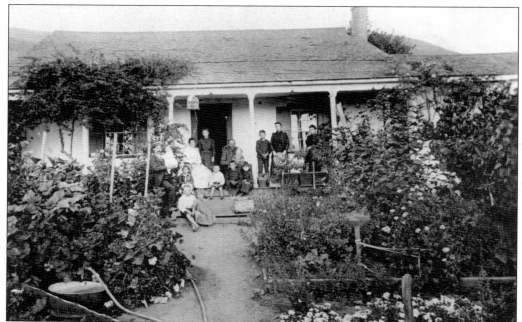

ANDREWS ADOBE, 1451 ANDREWS STREET. Built in the late 19th century by Indian laborers, the Andrews Adobe is believed to be one of the oldest surviving structures in San Luis Obispo County. Originally constructed as a one-story house, the edifice might have housed the manager of the mission in the early 1800s. Around 1870, prominent businessman and banker J.P. Andrews purchased the property and lived there with his family for many years. In 1906, at the age of 82, Andrews added a second floor. Today, the adobe is covered in clapboard.

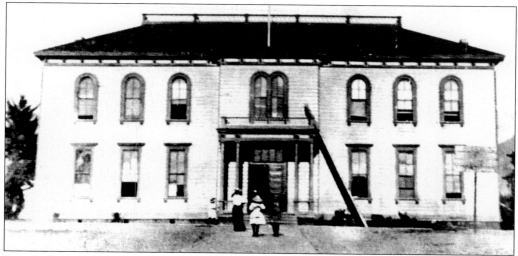

COURT SCHOOL. In 1876, the City of San Luis Obispo built one of the first public elementary schools, Court School, on a hill at the southeast corner of Santa Rosa and Mill Streets. A local carpenter constructed the redwood school—which was painted white—on land donated by prominent San Luis Obispo banker J.P. Andrews. Students parked their wagons, carts, and buggies in the shade of eucalyptus trees along Mill Street.

COURT SCHOOL, CLASSROOM, C. 1898. Eight 20-foot-square classrooms comprised the two-story schoolhouse. A wide central staircase led to the second floor, which housed the seventh and eighth grade classrooms. In 1895, the city's first high school opened, occupying the Court School's second floor until 1905, when a new high school was constructed a few blocks away on Marsh Street.

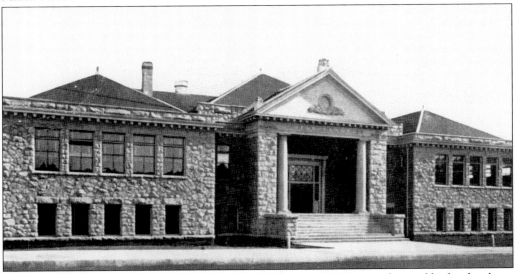

THE FIRST SAN LUIS OBISPO HIGH SCHOOL. In 1905, San Luis Obispo's first real high school was built on the southwest corner of Marsh and Toro Streets. Prior to its construction, secondary school students attended classes on the second floor of Court Elementary School, several blocks away. Constructed of granite blocks quarried at Bishop Peak, the new San Luis Obispo High School had hardwood throughout the building and marble counters in the lavatories. In 1928, the building became the junior high when a new high school was built across the creek on what is today San Luis Drive. In 1953 the granite high school was demolished.

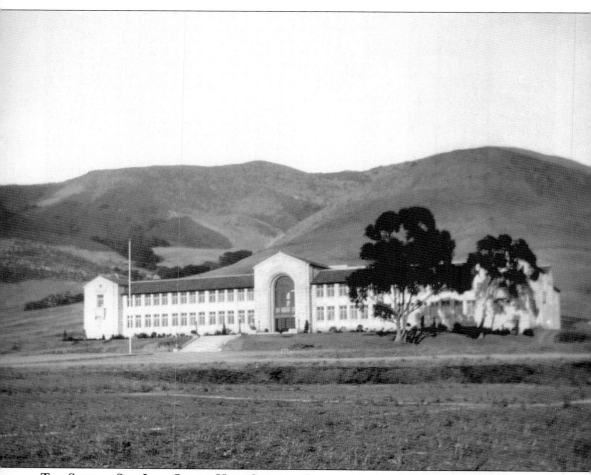

THE SECOND SAN LUIS OBISPO HIGH SCHOOL. Overcrowding at the Marsh Street high school led to construction of a new high school near San Luis Drive in 1928. Comprising 70 acres, San Luis Obispo High School had a large auditorium, spacious sports grounds, and a gymnasium that was added in 1936. However, engineers condemned the school as an earthquake hazard in 1962 and the structure was torn down. Students then attended classes in temporary huts while yet another, larger, "earthquake-proof" high school was constructed.

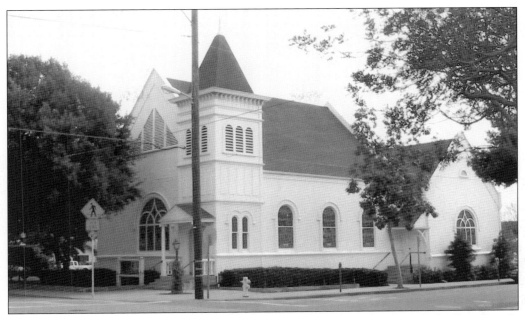

FIRST BAPTIST CHURCH, 1301 OSOS STREET, 2004. Though made of wood, the First Baptist Church was built to look like a stone Romanesque Church with its steep gable roof, arched, stained-glass windows, and belfry. The First Baptist Church was founded in the early 1880s and the building was constructed in several stages between 1895 and 1907. (Courtesy of the Franks Collection.)

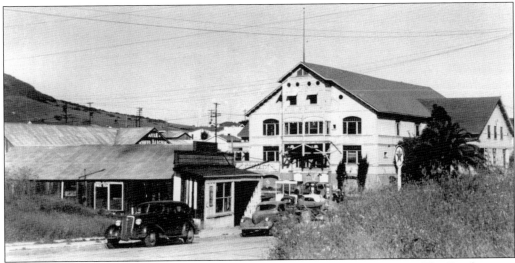

THE PAVILION, NORTHWEST CORNER OF MONTEREY AND TORO STREETS. The Pavilion was constructed in the 1880s as an agricultural exhibition hall. During the early 1900s, the hall was transformed into a theater where drama troupes provided "one-night stands" when they traveled between San Francisco and Los Angeles. Actress Lillian Russell, who once performed at the Pavilion, is said to have called the dressing room "the worst dump" she had ever been in.

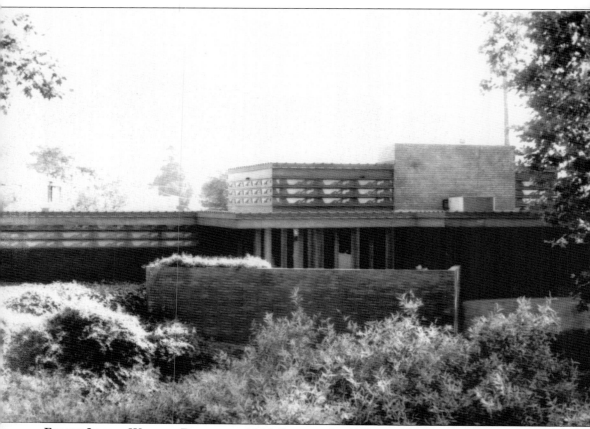

FRANK LLOYD WRIGHT BUILDING, 1106 PACIFIC. In 1953, world-renowned architect Frank Lloyd Wright designed a one-story medical building for San Luis Obispo ophthalmologist Dr. Karl Kundert. The Kundert Medical Building was a classic example of Wright's Prairie School–style, with low, horizontal, earth-toned rectangular units joined by a flat roof with wide overhangs. Wright's Usonian style was reflected in the brick he chose for the lower part of the structure and in repeated sections of carved wood and white glass for the upper portion. The late afternoon sun shone through the carved-wood window panels, creating a continuously changing pattern of light on the waiting-room walls. Furnished with Wright's custom-designed furniture, the waiting area showed a strong Japanese influence with its open floor plan and glass doors that visually incorporated the landscape into the building. Today, the building is a cardiologist's office.

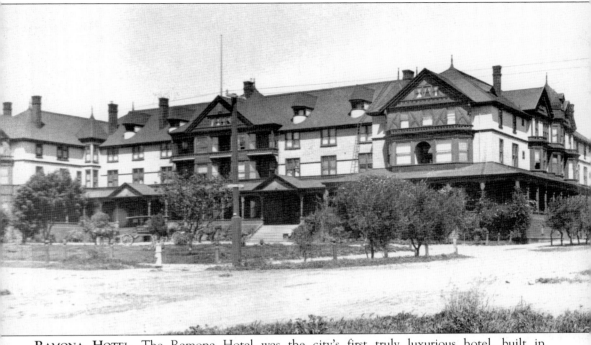

RAMONA HOTEL. The Ramona Hotel was the city's first truly luxurious hotel, built in anticipation of the Southern Pacific Railroad's arrival in San Luis Obispo. The hotel's name was chosen as a tribute to a popular novel of the time, *Ramona*, by Helen Hunt Jackson. The Ramona Hotel occupied the entire block bounded by Marsh, Johnson, Higuera, and Pepper Streets. Opened in October 1888, the four-story wooden Victorian hotel attracted visitors nationwide, as well as affluent local residents, all of whom enjoyed the Ramona's multi-course meals, elegant tea parties, and formal balls. The Ramona burned to the ground in 1905 and was never rebuilt.

RAMONA HOTEL, GUEST SUITE. Two hundred rooms and suites awaited guests eager to be pampered with modern amenities like hot and cold running water, gas and electric lights, and electric "call-and-return" bells that summoned the hotel's many servants. Multi-room suites had dumbwaiters for room service. Overnight accommodations cost $2 to $3.50 a day, and included breakfast, supper, and dinner.

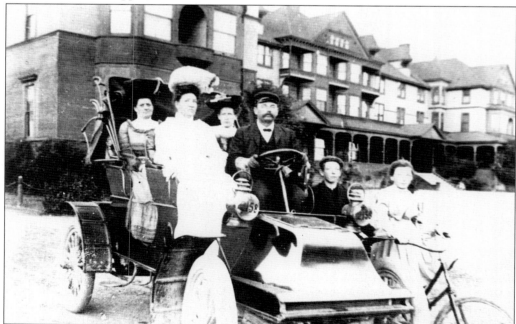

RAMONA HOTEL GUESTS. Guests arrived at the Ramona Hotel by horse and buggy, stagecoach, train, and later by automobile.

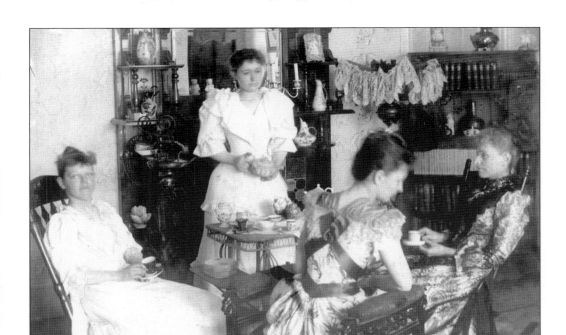

RAMONA HOTEL TEA PARTY. These society women are, from left to right, Gertrude Jack Kaetzel, May Sinsheimer, Gertrude Sinsheimer, and an unidentified woman. Such guests often "took tea" in the Ramona Hotel's parlor.

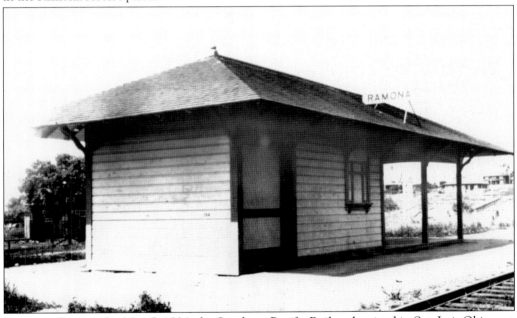

RAMONA DEPOT. On May 5, 1894, the Southern Pacific Railroad arrived in San Luis Obispo at the Ramona Depot, adjacent to the luxurious Ramona Hotel. In later years, the depot welcomed two U.S. presidents when they visited San Luis Obispo: William McKinley in 1901 and Theodore Roosevelt in 1903. The depot was later moved to the grounds of the Dallidet Adobe on Pacific Street, where it was restored in the 1960s.

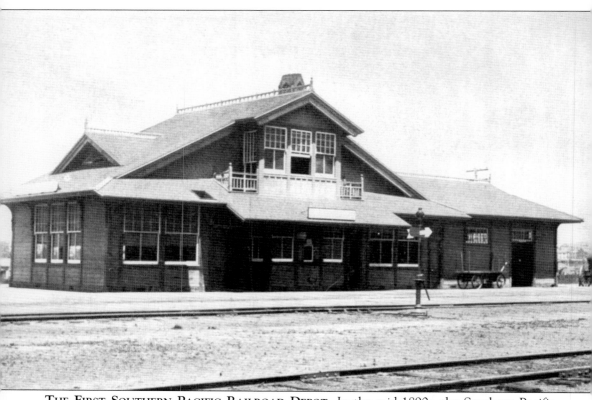

THE FIRST SOUTHERN PACIFIC RAILROAD DEPOT. In the mid-1890s, the Southern Pacific Railroad built a passenger depot adjacent to the railroad line between Santa Rosa and Osos Streets. A nearby cottage served as the conductor's room and soon a roadmaster's office was built. Passengers typically wore dark suits, hats, and gloves when they traveled by rail, and were welcomed to the depot by uniformed porters. In the early 1940s, the structure was converted into railroad administration offices and a new depot was built nearby. No longer used after the late 1960s, the old landmark was demolished in the early 1970s.

SOUTHERN PACIFIC RAILROAD FREIGHT WAREHOUSE. A freight warehouse stood a few blocks south of the passenger depot. Constructed of wood, the building's floor and platform consisted of asphaltum from nearby Price Canyon. The warehouse functioned as a freight transfer point for the Southern Pacific Railroad and for the Pacific Coast Railway, which had a spur track on South Street that ran to the warehouse. (Courtesy of the Franks Collection.)

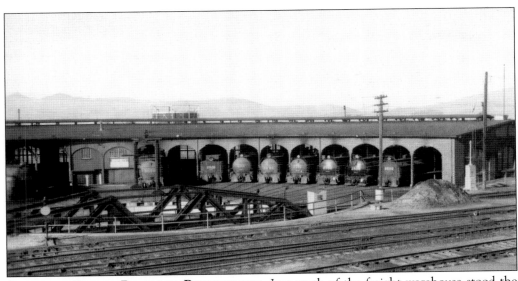

SOUTHERN PACIFIC RAILROAD ROUNDHOUSE. Just south of the freight warehouse stood the immense brick roundhouse, where locomotives were serviced.

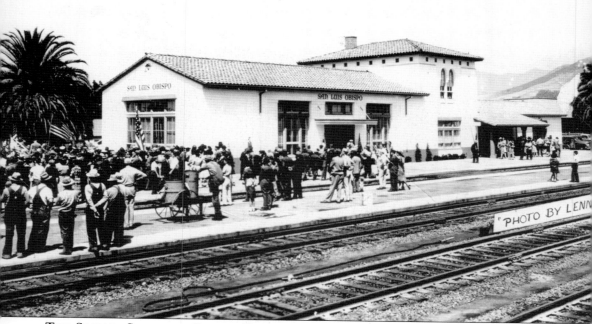

THE SECOND SOUTHERN PACIFIC RAILROAD DEPOT, 1011 RAILROAD AVENUE. Built in 1943, Southern Pacific's new Mission Revival–style depot stood just north of its predecessor. The 157- by 33-foot stuccoed building had a broadly pitched red-tile roof, brick chimney, and a two-story central section with tall, arched windows. Thick wooden columns supported the walkway overhangs, and square tile details adorned the base of the roofline. A 1942 *Telegram-Tribune* article reported that "the new station will have stuccoed interior walls, tiled floors, decorative ceiling timber trusses, and retiring rooms will be modern in appointments and all public facilities will be of generous proportions." Today, the structure functions as the Amtrak Station and is one of the few Mission Revival buildings remaining in the city.

RAILROAD SQUARE, 1880 SANTA BARBARA STREET. In 1912, a three-story brick warehouse was built near the railroad depot as a wholesale grocery outlet for Channel Commercial Company. The building served as the point of entry for most of San Luis Obispo's groceries until the advent of large, refrigerated trucks. The warehouse later became Railroad Square, an office building. A suspicious fire swept through the old warehouse in 2002, severely damaging the building. (Courtesy of the Franks Collection.)

MRS. M.J. SANDERS HOUSE, 1617 SANTA ROSA STREET. The home of Mrs. Sanders was once located in the railroad district.

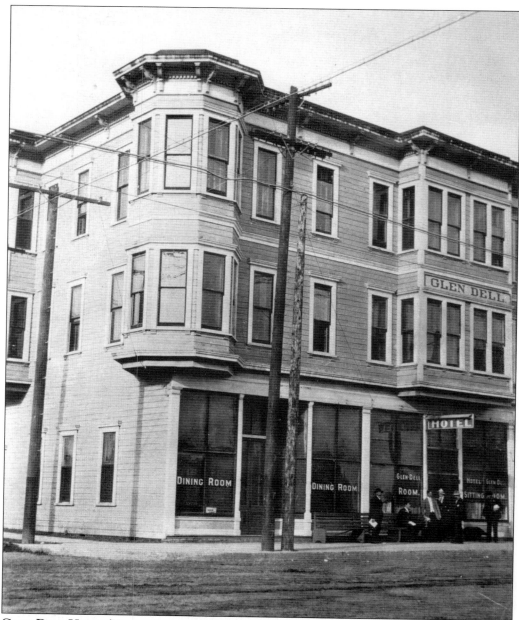

GLEN DELL HOTEL/HOTEL PARK, 1815 OSOS STREET. The three-story Glen Dell Hotel stood among several boarding houses built near the Southern Pacific Depot. Constructed *c.* 1910 for railroad engineer James Reidy and his wife, Dora, the Glen Dell provided long-term housing for railroad employees as well as overnight accommodations for travelers. In 1920, the boarding house became the Axtell Hotel, and in 1938, the Hotel Park. By the early 1980s, the structure had fallen into disrepair and was closed. In 1984, the historic hotel received a $1 million renovation. The upper floors were converted into 21 low-cost apartments, and the ground level into retail space for restaurants and shops.

VETERANS' MEMORIAL BUILDING, 801 GRAND AVENUE. Dedicated Memorial Day 1951, the Veteran's Memorial Building construction was a joint effort of San Luis Obispo County and the State of California. The hall became the center of activity for veterans' organizations and community events.

MONDAY CLUB, 1815 MONTEREY STREET. Julia Morgan, the architect of Hearst Castle, also designed the Monday Club, built in 1933. The eclectic-style clubhouse has a Spanish tile roof, decorative ironwork, and Romanesque arches, all combined in a low, linear Craftsman style. Morgan created an interior resembling a garden gazebo, with murals of loquat trees, an awning above the stage, and Chinese lanterns. The Monday Club was founded in 1925 for civic, social, and cultural purposes. (Courtesy of the Franks Collection.)

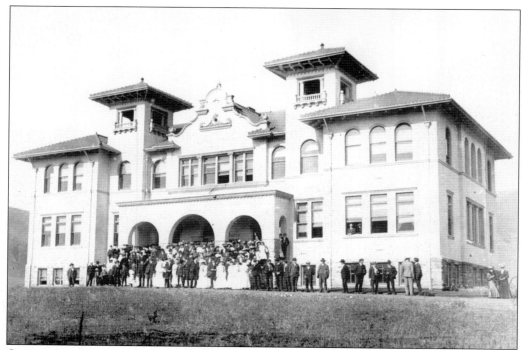

CALIFORNIA POLYTECHNIC STATE UNIVERSITY, ADMINISTRATION BUILDING, C. 1903. In 1902 renowned architect William Weeks designed the first structures of what was to become California Polytechnic State University. Pictured here is the Mission Revival–style administration building, which also included classrooms. The school, laid out on 281 acres northeast of the city, was the inspiration of pioneer historian, newspaper editor, and civic booster Myron Angel. Angel wanted to create a campus that combined the practical, hands-on instruction of a "farm" campus with the curriculum of East Coast institutions of higher learning.

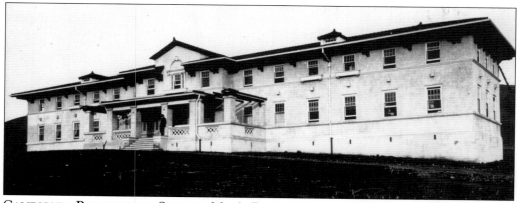

CALIFORNIA POLYTECHNIC SCHOOL, MEN'S DORMITORY, C. 1903. One of the school's first structures, the men's dormitory stood on a hill overlooking the railroad tracks. Today California Polytechnic State University's education and business buildings are located on this site.

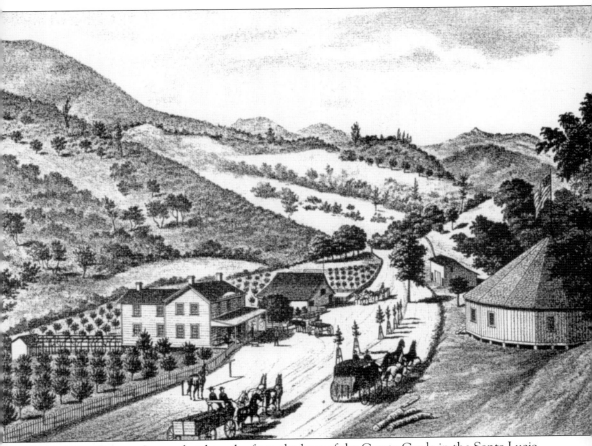

EIGHT MILE HOUSE. Located eight miles from the base of the Cuesta Grade in the Santa Lucia Mountains, Eight Mile House offered overnight lodging to stagecoach travelers in the late 19th century. The hotel, owned by farmers Edwin and Reuben Bean, stood among 183 acres sheltered by surrounding hills. Sixty acres were planted with more than 800 fruit and nut trees, as well as strawberry bushes and grapevines. The remaining acreage was set aside for grazing cattle and logging. The two-story, L-shaped, clapboard hotel had a wide front porch, capacious stables, and, across the road, a 61-foot-diameter octagonal dance hall. Eight Mile House's pleasant location, mild climate, and comfortable quarters made it a popular health resort for visitors from the Tulare Valley. During harvest season, farmers and teamsters hauling wood and produce to market also enjoyed the facilities. The hotel could lodge as many as 50 overnight guests and stable 130 horses.

LAST CHANCE SALOON. Business entrepreneur Virginia King opened the Last Chance Saloon at the foot of the Cuesta Grade just north of San Luis Obispo in 1895. In theory, King's establishment was the traveler's "last chance" to quench his thirst and lift his spirits with a drink before the long climb to the summit. A large fireplace and long bar welcomed guests into the wooden tavern. During Prohibition, the Last Chance Saloon officially closed, although its female employees found other ways to make a living in the 20 rooms that stood behind the tavern. In the 1930s, the Last Chance reopened in anticipation of GIs arriving at Camp San Luis Obispo as World War II approached. However, the military declared the saloon off limits and ended its days as a place of entertainment. In the late 1940s, the property became a veterinary hospital and then changed hands several times until the last owner tore down the old building in 1970.

MILESTONE MO-TEL/MOTEL INN, 2223 MONTEREY STREET. The Milestone Mo-Tel—later known as the Motel Inn—opened its doors in 1925. Billed as the world's first motel, it served as one of San Luis Obispo's best steakhouses and most popular watering holes. The brick and stucco Mediterranean building with multiple gables and red-tiled roofs offered motorists a place to rest, relax, do laundry, and buy groceries. The main building supported a dome-shaped tower with a copper roof. Guests stayed in separate bungalows facing a central courtyard. Each room had an indoor bathroom—a luxury at the time—a telephone, and garage. Some units had kitchenettes. An orange tree grew outside each bungalow's door and guests were encouraged to pick the fruit. The now-boarded-up motel is slated for restoration to its original style.

MADONNA INN, 100 MADONNA ROAD. San Luis Obispo ranchers, developers and construction company owners Alex and Phyllis Madonna built the world-famous Madonna Inn between 1958 and 1969. Painted pink, Alex Madonna's favorite color, the American Folk/Pop-style motel resembles a Hansel-and-Gretel–style structure with Swiss chalet overtones and Queen Anne–style turrets and towers. Located just off California Highway 101, the Madonna Inn is a highly visible cultural landmark.

BISHOP PEAK QUARRY. At the turn of the 19th century, two granite quarries operated on Bishop Peak, northwest of San Luis Obispo. Workers blasted the side of the mountain with explosives, slid the large rocks down the steep embankment, and then hauled them by horse-drawn carts or rail to construction sites, where they were cut, shaped, and polished.

WAITE PLANNING MILL AND MACHINE SHOP, 246 HIGUERA STREET. H.H. Waite also operated a foundry in this false-front building on Higuera Street.

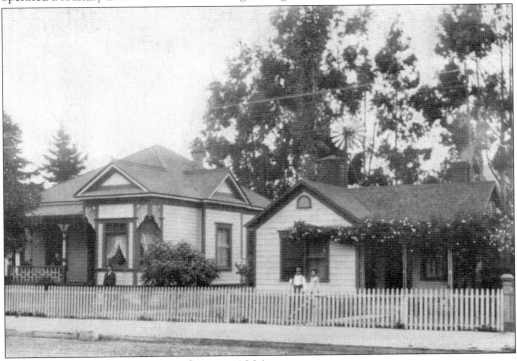

WARNER HOUSE, 444 HIGUERA STREET, 1904.

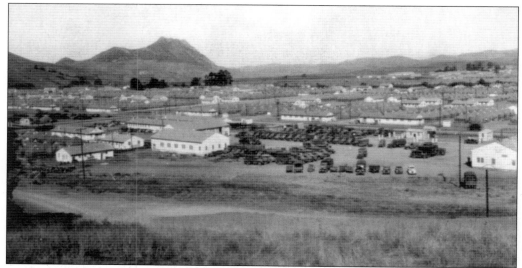

CAMP SAN LUIS OBISPO, HIGHWAY 1. Between 1940 and 1942, the U.S. War Department constructed Camp San Luis Obispo, one of the largest training facilities during World War II. Located just north of town, the camp occupied the former National Guard training grounds, plus an additional 5,000 acres of adjacent land the government leased from local farmers and ranchers.

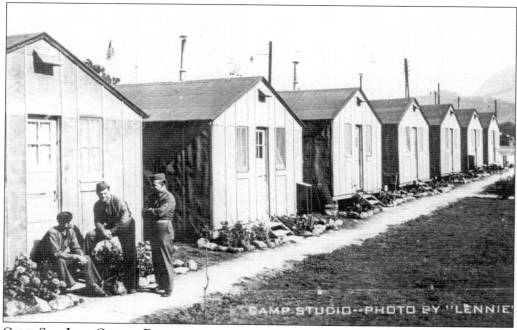

CAMP SAN LUIS OBISPO, BARRACKS.

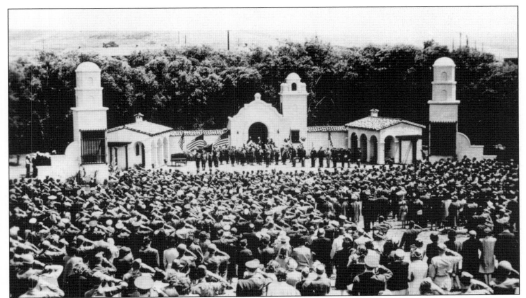

CAMP SAN LUIS OBISPO, MEMORIAL AMPHITHEATER. This Mission Revival–style amphitheater provided a place where servicemen could relax and be entertained.

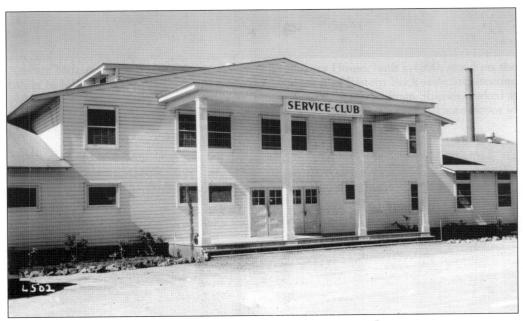

CAMP SAN LUIS OBISPO, SERVICE CLUB.

DAIRY BARN, EDNA VALLEY, 2004. In the late 1860s, the Steele brothers established the dairy industry in the Edna Valley, where barns like this one were constructed throughout the area. This 8,000-square-foot barn, built *c.* 1909, has a Jackson hayfork, which once lifted hay from one side of the barn to the other and still hangs today from a pulley system that spans the ceiling. (Courtesy of the Franks Collection.)

EDNA STORE, CORNER OF PRICE CANYON AND EDNA ROAD, EDNA VALLEY. The Edna Store operated as a general merchandise store and dance hall in the early 1900s. Owned by John Tognazzini, the store functioned as a post office in its later years. In 1948 the building became an antique shop. (Courtesy of the Carpenter Collection/SLOCMHC.)

CORRAL DE PIEDRA SCHOOL, EDNA VALLEY, 1959. The Corral de Piedra School, constructed c. 1899, educated Edna Valley children for the first half of the 20th century. The school consisted of two classrooms formed by a curtain that hung from the ceiling. Later, another classroom was added on to the rear of the schoolhouse. The school closed in 1958 and burned down in 1959, four months after this photo was taken.

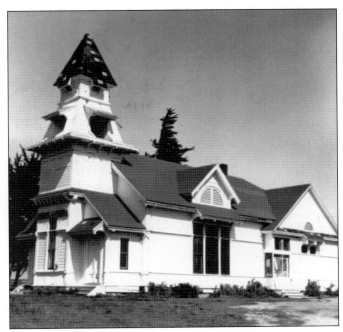

INDEPENDENCE SCHOOL, CORNER OF ORCUTT AND RIGHETTI ROADS, EDNA VALLEY. The Independence Schoolhouse was built in 1919 to accommodate the growing number of school-age children living in the Edna Valley. Painted red with gray trim, the wooden schoolhouse covered about 850 square feet and had 18-foot ceilings, heavy-framed windows, and a bell tower. Blackboards lined the entire north wall, and a wood stove in the center of the room took the chill off cold winter days. The school closed in 1956 and later became a residence. Today, the old schoolhouse is the tasting room for Baileyana Winery. (Courtesy of the Carpenter Collection/SLOCMHC.)

SAN LUIS OBISPO, 1956.